# ITALIAN DRAWINGS

# DRAWINGS OF THE MASTERS

# ITALIAN DRAWINGS

## From the 15th to the 19th century

Text by Winslow Ames

LITTLE, BROWN AND COMPANY · BOSTON · TORONTO

LIBRARY OF CONGRESS CATALOGING IN PUBLICATION DATA

Ames, Winslow.
   Italian drawings from the 15th to the 19th century.

   Reprint of the ed. published by Shorewood Publishers, New York,
in series: Drawings of the masters.
   1. Drawings, Italian. I. Title. II. Series: Drawings of the
masters.
NC255.A43  1976      741.9'45     76–2076
ISBN 0–316–03688–9

Published simultaneously in Canada
by Little, Brown & Company (Canada) Limited

PRINTED IN THE UNITED STATES OF AMERICA

# Contents

## ARTISTS AND FIGURES IN TEXT

## ARTISTS AND PLATES

# Italian Drawings

Drawing formed the basis of most of the art of the Renaissance. In the centuries covered by the group of reproductions in this book Italian drawing partook fully of that great European movement. Many collectors and critics have said that both drawing and painting went into the doldrums after Guardi (in the eighteenth century). Here then, we see only the splendid conclusion in Guardi's Venice of a long tradition that began in Verona and Florence in the late fourteenth century.

Despite the loss of over 90 per cent of the drawings produced in those centuries we still have a great legacy, larger numerically than that in almost any other field of activity outside the areas of multiple production—printed books, fine prints and pottery. Such a collection as follows is a choice of choices, containing, obviously, many tried-and-true favorites and a few genuine novelties and surprises. Although the editors might have chosen different and equally good examples from the same master's hand it would not have caused me to alter what I want to say about some of these Italian draughtsmen and their drawing in general, its purposes and methods.

Almost all the drawings in this book are preliminary studies to ampler works in painting, occasionally in sculpture, architecture, or even such a relatively minor art as embroidery. Ordinarily they are drawn on paper which is not completely covered by the artist's handwork—as, for example, the canvas is covered in an oil painting or the paper in many modern water colors. Within the broad embrace of drawings selected for this book are great varieties of workmanship and intention.

In the painting of much of our time there has been an art to conceal art —that is, the paint was applied in such a way that the beholder does not readily see on the surface how the effect was produced. This is not so in drawing where the handwriting-like method and instruments leave the process exposed to the eye.

Why does anyone draw? We all scribble from time to time. Given the will

Figure 1

ITALIAN, Lombard Early 15th Century • *Sheet from a Pattern Book* • pen and wash on vellum, 239 x 171 mm.
New York, The Pierpont Morgan Library

to learn, any intelligent person can probably be taught to draw what is set before him with some degree of academic correctness. Drawing is useful. It may be a preliminary sketch in which the artist's idea emerges before it is worked over and placed in a more permanent form. Also, drawing leads to an analysis and understanding of the very nature of things. What makes the magical difference between merely well-instructed or clever manipulations of the amateur and the eloquence, force, economy, and lightning-like perception of a drawing by a real artist? It is partly a question of vocation. Perhaps, above all, it is the result of a yearning and a power to penetrate, seize, and master the secret organization of nature with one's own hands. Others have the vocation to do much the same thing with a microscope.

In this volume we are not concerned with the problem of non-representational art. We may therefore speak of representation in a broad sense—as *re*-presentation, just as recreation may be a *re-creation* of the person. With an image in his mind's eye and pen, brush or crayon in hand, the artist has something to present to us about a fact or relationship in nature—perhaps nature idealized by his own imagination. With his drawing tool, he *re*-presents this fact or relationship so that our outward eye may see it as readily as his inward eye did.

Man likes to place himself, to know where he is, who he is, with what he has to deal. The artist's way of orienting himself is to give through his eye and hand a sort of permanence to circumstances, however transitory. When the rest of us find that an artist's images speak to our experience, we make this permanence even more literal by keeping his work.

The Renaissance, moving first and for some generations most actively in Italy, made man feel the need to master the secret organization of nature. Many things that had been taken for granted were no longer accepted. Man took to examining mankind, its shape and its thoughts, its relation to nature and God. In much of this examination, drawing played a large part. Although

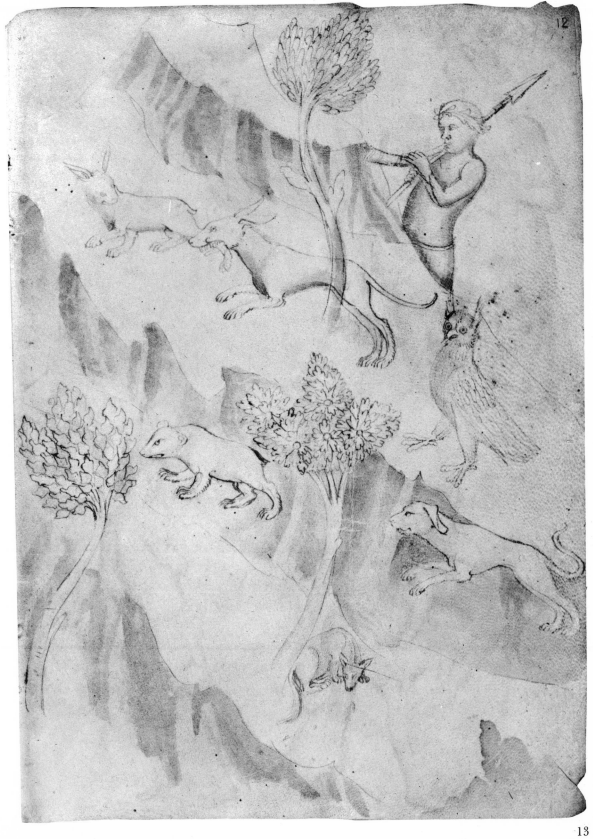

the Renaissance tended to skip back to ancient classic civilization, beyond the Gothic and Byzantine, in search of mankind's previous "best", there had been two factors contributing to the early Renaissance draughtman's capacity. One was the empirical science which the Moslem world, pressing upon the West, contributed; the other was the monastic copying of manuscripts which not only preserved the Bible and much classical learning, but also gave the artist both the formal task of illustration and informal outlet (in marginal flourishes) for his freer thoughts. Moslem medicine and its Western successors provided a certain analytic way of looking at mankind. The varieties of writing and drawing practiced in the Christian scriptoria of the West encouraged some versatility and individuality.

So our story starts at a point for which there had been long preparations —where admittedly rigid late-Gothic methods could produce charming insights (e.g. The Pierpont Morgan Library's Pattern Book, Figure 1). The *bottega* or artist's workshop at the beginning of the fifteenth century was organized for division of labor. The chief was responsible for a sort of trade family as well as for his own family—living upstairs over the shop. His trade as an artist was generally thought comparable to those of the weaver, druggist or lawyer. He employed journeymen. He kept a school of sorts. Apprentices were bound to him for a term of years. He had a file of patterns—and kept trade secrets in his head. He was not working in a vacuum under "inspiration" although he had that too if he were good—but producing for a demand. His customers were the church, guilds of other trades, individual donors to parishes or guilds, and later, individuals who ordered works of art for themselves or commissioned buildings to house their families or their enterprises.

The master himself had been an apprentice, beginning by grinding his master's colors, grounding panels with *gesso,* stretching canvases, sharpening chisels—sometimes standing as model for a figure study (e.g. Davide Ghirlandaio, Plate 17). When the apprentice began to draw it was often by copy-

ing his master's drawings. Leonardo, Michelangelo, Giovanni Bellini and Tiepolo did this. Although art was a "trade", the Renaissance admiration for the artist and his accomplishment raised some master artists to the social level of their greatest patrons (employers). Albrecht Dürer wrote home from Venice about 1500: "Here I am a lord." But we are not here concerned with society. I shall return to the matter of certain types of drawings after saying something of Italian regions and their artistic rivalry.

The power and variety of Italian drawings stem from the diversity and competition of the Italian city-states. Particularly northward from Rome, by about 1400 these had become solid clusters of people, some of whom went out into the countryside to work but more of whom were already living the urban life as we still know it in urban neighborhoods. Each city-state had its special character, its own well-known "cash crop" or product, sometimes things—such as woolen and linen cloth—sometimes mercenary soldiers exported to fight other people's wars. Artists were needed who could turn their hands to face-painting, making altarpieces, decorated chests, trinket boxes, pictorial covers for bound volumes of city records, processional banners and designs for domestic embroidery, or modeling and casting doorknockers and table-bells. Some cities had a feudal sort of patron (like the duke of Urbino). In Venice there was an oligarchy. The ascendancy of different cities at different times brought working artists from elsewhere to them (as Flemings flocked to Rome in the late sixteenth century). But each city-state maintained its artistic character or "signature." Although some of them declined from eminence early, all of them contributed to the richness of Italian artistic production. Nowadays we tend to polarize the fifteenth century around Verona and Florence; the sixteenth around Venice and Rome; the seventeenth around Bologna and Naples; the eighteenth around Venice and Rome—but this oversimplifies matters. Siena, Urbino, Genoa, Arezzo and Milan all had their days.

The subalpine plain was a center of draughtsmanship. Milan, on the west or Lombardic side, was the base for travel across the Simplon Pass. It attracted artists from north and south who worked on the Cathedral, begun before 1400 and worked on into the fifteenth century. Until the time of Leonardo, the reigning Sforza dynasty did not attract many well-known draughtsmen although they certainly employed illuminators, jewelers and architects. Bramante (Plate 5) worked in Milan for almost twenty years, leaving with Leonardo when the Sforza fortunes failed in 1499. It is hard to imagine modern industrial Milan in terms of a late medieval city, but so it was when Leonardo lived and worked there and helped to change its face. Leonardo's strange, troubled, inventive facility combined with extraordinary powers of observation and curiosity about nature have earned him the reputation of a universal genius. He was probably more lopsided than that, but his drawings are a vast and hugely varied range from the exquisite (Plate 57) to the eerie (Plate 56). Leonardo left a following in Milan which took up and exaggerated his smokier, mysterious, and sentimental aspects. A pioneer work, such as Leonardo's landscape (Plate 52) was not echoed until several generations later, and then largely by northerners who had crossed the Alps. Although Plate 5 was drawn perhaps in Urbino rather than Milan by Bramante while he was still primarily a painter rather than an architect, one sees in its diagonal hatching a certain kinship to Leonardo's modeling.

Verona at the opposite end of the Lombard plain was also a crossroads. Travel over the Brenner Pass led through it, and it was near the active port of Venice. A great number of drawings from Verona has come down to us, and, as yet, scholars have not disentangled the identities of all the artists. Plate 1 by Altichiero da Zevio is the earliest of our illustrations, and typical of the old method of passing down patterns from one generation of artists to another. In Pisanello (Plate 25) we see a more fully Renaissance personality in search of facts and form. The artists of Verona seemed to have viewed life

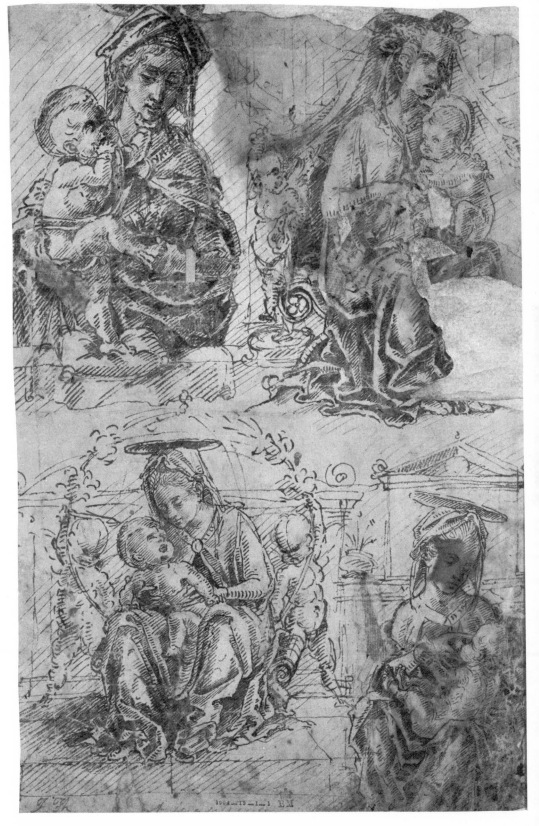

Figure 2

ZOPPO
*Four Studies of the Virgin and Child*
pen and ink, 274 x 182 mm.
London, The British Museum

affectionately. But Pisanello, who worked also in Naples, Rimini, Mantua and Venice as a painter, medalist and architect, drew whatever subject roused his curiosity. He was one of the first draughtsmen of the female nude. To increase his knowledge, he was evidently glad to draw a dead man, a dead dog or bird. His pen was always carefully descriptive and his outlook fresh.

Padua, nearer to Venice than Verona, was, so to speak, fructified by the work there of the great Florentine sculptor Donatello, who inspired Mantegna to such an extent that traces of the late Gothic cannot be detected in his work. Mantegna is perhaps more sculptural in his painting and more devoted to classical antiquity in his choice of subjects and style than many other early Renaissance artists, but his drawings are among the boldest and most eloquent of his generation. His figures expressed an understanding of the body which was almost that of a dancer.

Zoppo, a draughtsman from Bologna who also worked in Padua, acquired something of Mantegna's way of drawing. Indeed, in the whole region of Padua, Bologna, Ferrara and Mantua (where Mantegna did much of his work) there was a tendency in drawing to use consistent contour lines and systematic diagonal shading which may look hard and metallic in the hands of some Ferrarese artists, a little wild with Zoppo, almost soft with Francia. Francesco del Cossa (Plate 30) and Ercole de' Roberti (Plate 38) both drew in a rather angular manner but their subjects were often tender.

In all this geography, Mantegna had another link. He was the brother-in-law of Giovanni Bellini, of the second Bellini generation of Venetian artists. His father-in-law, the old Jacopo Bellini (Plate 23), was a late-Gothic draughtsman in most respects, but his compositions were highly inventive. His sons and son-in-law built upon his practice—occasionally using his stock of compositions or *simili* a less graphic, much more painterly sort of drawing, a newly colorful painting that was rich in sensuous values in contrast to the intellectualism of Florence.

Venetian drawing emphasized masses and the light and shade upon masses. Florentine drawing dwelt upon silhouettes, structure and the appearance of motion. When Bonsignori (Plate 37) worked in Venice, he adopted the luminous suggestive modeling of Giovanni Bellini (Plate 26) or Alvise Vivarini (Plate 27). Oddly enough, the brief visit in Venice of the Sicilian, Antonello da Messina (Plate 31), whose works had certain Flemish characteristics, had a powerful influence as a sort of common language as comparison of the last four mentioned drawings will make clear.

While Venetian art was enjoying the sensation of receiving messages from the eye—as Impressionism was to do in the nineteenth century—Florentine art was transmitting messages—from muscle to muscle—through the eye. As the reader will observe, particularly in the drawings in dark and light on medium-toned grounds (Plate 7), the Venetian draughtsman noticed and recreated in his own shorthand the presence of some light in shadows and some pockets of shade in lighted surfaces. The Florentine draughtsman concentrated on those turning-edges or meeting-lines of planes where the strongest lights and darks seemed to lie (e.g. Fra Filippo Lippi, Plate 10). Even when the dominant brush-drawings of the late fifteenth century in Venice were superseded by the black and white chalk drawings on blue paper of Titian and Tintoretto, the attitude toward the task of drawing remained much the same. Comparison of Plate 44 or Plate 54 to Plate 60 or Plate 76 will demonstrate the difference between the Venetian and Florentine viewpoint and method.

In Florence in the days when the Medici were still leading citizens—not grand dukes—the earlier Florentine artists investigated all facets in the pursuit of truth. Under the aegis, so to speak, of Giotto's greatest frescoes, they combined science and art by the study of anatomy and perspective. Among the most satisfactory results of their activity was the discovery of form through drawing. In the work of Uccello, Domenico Ghirlandaio, Lorenzo di Credi,

Verrocchio, Piero di Cosimo, and above all, Pollaiuolo, one feels the young spirit and all of the excitement of the chase. Although these Florentines, including, of course, Leonardo who spent the third decade of his life in Florence, were more interested in how the body worked than in the visual pleasures of its surfaces (which the Venetians enjoyed), there is in their figure studies an appealing liveliness or elegance of stance which makes up for the lack of sensuousness. In Pollaiuolo's work there was a whole-hearted interest in the purely physical which combined with the passion of the provincial Signorelli to pave the way for the work of Michelangelo.

In Parma, midway between Milan and Bologna, the Po Valley produced two great figures whose works took two different directions from Michelangelo's. Antonio Allegri, nicknamed Correggio from his birthplace near Parma, forecast the grand motion and soft luxury of the style—a century later—we now call Baroque. Parmigianino (Figure 4) was one of the prime creators of the elegant elongated Mannerist style of the later sixteenth century.

Umbria, the more mountainous region north of Rome and southeast of Tuscany, was relatively isolated artistically speaking. But a tiny metropolis, the court of Urbino, employed artists as fine and varied as Piero della Francesca and Raphael (Plate 66). Umbria also produced Perugino (Plate 64, 65), Pinturicchio (Plate 67, 68) and the metropolitan Raphael. In the Umbrian character there was none of the cross-grained quality we expect of men in hill country, but a genuine serenity which could appear as blandness or "sweetness and light." But, at its best, it was pure, compact, and naïve in the good sense of the word. Oddly enough, Cortona, in Tuscan territory on the borders of Umbria, was the birthplace of Signorelli, the violence and emphatic articulation of whose designs were as different as possible from the Umbrian tranquility. Also born in Cortona was Pietro da Cortona (Plate 85), one of the central figures of the Roman Baroque style.

In the middle of the fifteenth century the secular power of the papacy became apparent and distinguished painters, architects and sculptors from all Italy were called to Rome. The exposure to different styles made the artists who worked in Rome lose some of their provincialism. Pinturicchio was one. Michelangelo worked there for years after his Florentine period, and Raphael spent much of his mature life in Rome. In the seventeenth century Rome was the real center of Baroque splendor. Two very great French painters, Poussin and Claude Lorraine, worked there most of their lives. After the Carracci left Bologna for Rome, a great decorative style grew up there. The reputation of Rome as a great center of art was maintained into the eighteenth century by the transplanted Venetian, Piranesi (Plate 96) and the Italianized Fleming such as Vanvitelli (Plate 88).

Although Florence continued to produce excellent draughtsmen until the seventeenth century, the great period had been the last quarter of the fifteenth and first quarter of the sixteenth century. Perhaps Botticelli (Plate 20) was the perfection of the generation after Pollaiuolo (Plate 11, 12) as Andrea del Sarto (Plate 63) was of the generation after him. But Michelangelo, however, was the crown of the movement, for he profited not only from Pollaiuolo and Signorelli but also from Leonardo. We see his mysterious complexity in even a few of his drawings (Plate 52, 53, 56) and observe the tortuous doubts that seem to paralyze the physiques of some of his powerful drawings, but it did not prevent him from turning out a great body of work in many mediums.

The easy, noble, spacious style of Bologna, seen in the work of Cavedone (Plate 84), the Carracci (Plate 74, 86) and Guercino (Plate 82), contributed along with the more excited manners of Naples and Genoa to the seventeenth-century grandeur of Rome. Castiglione (Plate 83) also traveled from his home in Genoa all over the Italian peninsula spreading the Baroque free-drawing style. Holding his brush at arm's length, he used thin red paint as

"ink" and washes of sky blue. His endless invention on pastoral subjects have given us drawings that are nearly painting but still graphic. Two generations later, Magnasco (Plate 89), another Genoese, has had his own mysteriously exciting and luminous equivalents for the lights and gaieties of Venice.

In the eighteenth century, English, French, Russian and even American travelers and collectors of art were attracted to Venice, the city in the sea—no longer a naval power but a place of entertainment. Because of this demand, many Venetian drawings were made for sale as works of art and not as preliminary studies to a painting. Many of the drawings by Piazzetta (Plate 92), Canaletto (Plate 93) and the Tiepolos (Plate 90, 91) were so intended. In what might be called the silver age of Italian art, the unique land-and-water situation of Venice never failed to attract artists—the glitter of the multiple reflections, from water, sunlit walls and pavements runs through all they did—especially in Guardi's paintings and drawings (Plate 95). Giovanni Battista Tiepolo (Plate 91) not only echoed the great compositions of Veronese (Plate 48) but created a world of sun, shadow, space and levitation like nothing in the romantic or classic memory.

In spite of great losses, we still have an enormous body of Italian drawings. We may safely assume that the best drawings have not always been the survivors. Fire, sword, false modesty, weather and neglect have removed the good as well as the bad. But there has been a tendency (in Jane Addams' phrase) for the excellent to become permanent. Furthermore, except where corrosive ink compounds have eaten into paper, a drawing on sound all-rag paper may last longer than a painting on canvas. Since the sixteenth century, collectors, except where they have contributed to the deterioration of drawings by exposing them to strong light, contributed to general knowledge as well as to their own pleasure by keeping and comparing drawings. Giorgio Vasari (1511-1573) of Arezzo, Florence, and Rome was not only the biographer

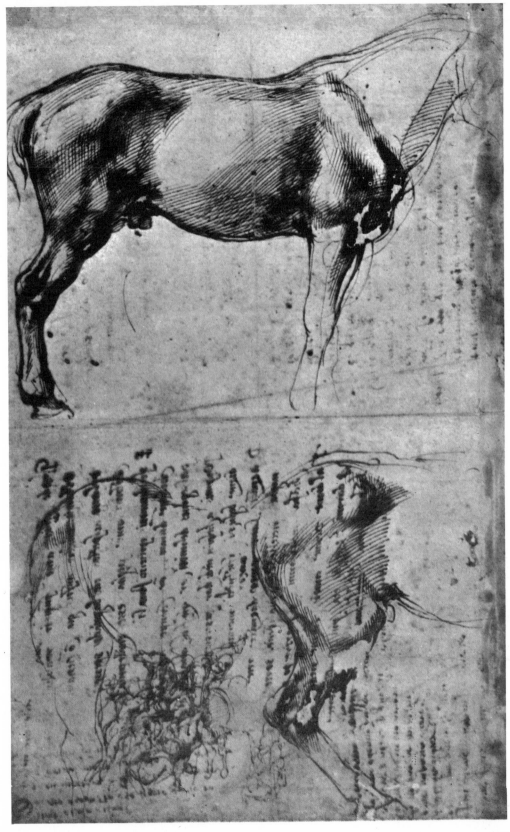

Figure 3

MICHELANGELO
*Studies of a Horse and
of a Horseman Attacking Footsoldiers*
pen and ink, 427 x 283 mm.
Oxford, Ashmolean Museum

of contemporary and earlier artists but also a systematic gatherer of drawings which he mounted in volumes within borders of his own design. The Milanese priest Sebastiano Resta (1635-1714) preserved after Vasari's time the work of artists he admired. The Moscardo family of Verona owned until about 1920 a great treasury of fifteenth- and sixteenth-century drawings—largely north Italian. Since the eighteenth century, there have been many artists and collectors outside of Italy to assure posterity for Italian drawings even after the great pioneer collections were dispersed. Without their work and that of such modern writers as Berenson, the Tietzes and Popham we should be able to know and enjoy even fewer drawings than we now can.

Although this volume contains few designs for architecture or sculpture, these represent the full range of types produced in Italian painters' *bottegas*. The earliest preserved drawings were usually *simili* (Plate 1) which were the standard stock of conventional compositions and figures of the more popular saints. These were often drawn on vellum for permanence. As they were intended as a matter of record, they were not often spontaneous in execution. However, the apprentice who was building up his own future studio properties by copying the master's drawing may have given us the sudden illumination of a new experience.

In the early Renaissance, every artist used a notebook regularly whether he was apprentice, journeyman or master. The leaves of the notebook were generally about one-eighth of the full sheet of the handmade paper of the day. Normally these leaves were prepared by applying with a wet sponge or flat brush a thin layer of powdered bone with a little color ground in. When this layer was dry it could be burnished, but usually it was left with a dull or matte finish. This grounding of the paper had a slightly abrasive texture and made it possible to draw with a stylus of silver which would have left no trace on the untreated paper. On this white or tinted surface, fine lines were left which oxydized to gray or brown and became indelible. A bit of

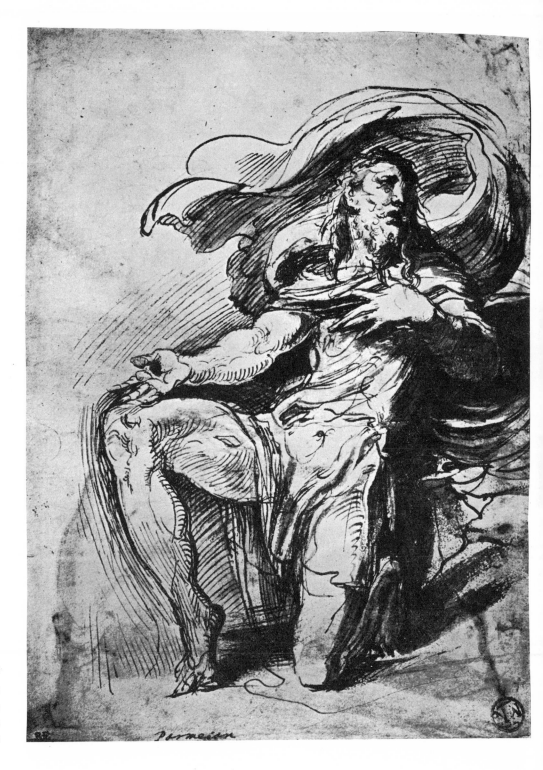

Figure 4

PARMIGIANINO
*Saint Roch*
pen, brown ink and brown wash
200 x 148 mm., Paris, Louvre

steatite, gypsum or white chalk added white heightening to tinted grounds. In his workshop, the artist could use liquids—white zinc or white lead applied with a brush. This three-tone effect suggested fuller color and the illusion of relief and roundness where crosshatched shading and the white heightening coincided. Other metal points, such as copper, sometimes substituted for silver. Silverpoint lines were sometimes strengthened with pen and ink, but this was rather dangerous for the surface was highly absorbent and wrinkled easily.

The chief virtues of a grounded notebook were that one did not have to carry wet ink about and that the silverpoint did not require sharpening as does chalk or charcoal. The small Leonardo *Horse and Rider* (Plate 53) is an example of the notebook sheet. The Perugino *Man in Armor* (Plate 67) is an example of a silverpoint drawing on a colored ground with liquid heightening added. The latter is even more interesting because it is also a young artist's translation of a motif from an older art. The model in this instance was Donatello's statue of St. George which Perugino saw in Florence when he was about twenty-five years old. The sculpture had been standing in its place for about sixty years.

From *simili* and notebooks an artist could demonstrate his wares to a possible patron. When he and the patron had worked out a notion of what picture was desired, the artist undertook trial compositions in sketches, at first rapid—then more careful. For such sketching the artist normally employed pen and ink on white paper. Masses were sometimes blocked in tentatively with charcoal which could be brushed off or blown away later. Throughout the period covered by this volume, the ink was a stain made from a gallic acid (from oak galls) and ferrous sulphate (iron rust usually) which, when dry, was more or less black but eventually turned brown or gray. Permanent black could be achieved by using lampblack, or some source of carbon, ground into a solution of gum arabic.

The pen was usually a goose quill, although the quill from a crow was used for very fine work. Like anyone who wrote with a pen, an artist needed a penknife always at hand for re-cutting the slightly-slanted point and for slitting it. A reed could be cut to shape for very bold broad strokes.

Among the illustrations in this volume, good examples of composition are sketches by Zoppo (Figure 2), Piero di Cosimo (Plate 21), although it has been cut and reassembled, and a sixteenth century unknown Venetian artist (Plate 42). There is an addition in the two latter drawings, common in such compositions, of diluted-ink wash put in with a pointed soft brush which suggests color and background in Piero di Cosimo's and gives form to the later Venetian sketch.

When a composition was determined to the satisfaction of client and artist, a *modello* or definitive composition might be drawn as part of the contract—as blueprints form part of a building contract today. Such a contract drawing was generally in pen and ink and wash, sometimes with a little water color or white heightening if drawn on toned paper. Examples in this volume are Plate 4, Plate 80 (although it has been cut and reassembled) and perhaps Plate 89. A successful painting which may have differed little in the execution from the *modello* was often recorded in the studio by a drawn copy. The careful *ricordo* after Catena (Plate 36) is almost certainly one of these, as is the Giorgionesque brush drawing (Plate 43).

During the actual work on the commission, details were studied separately and at a larger scale than in the composition drawings. Figures particularly needed to be studied for their poses, costume and facial expressions.

Studies were ordinarily done in black or red chalk, sometimes over a rapid preparation in charcoal. In order to give the illusion of third dimension the paper was given a wash of color. After the introduction of colored papers—blue, tan and other tints—white chalk was added for highlights. Complicated poses or difficult postures—as when flying figures had to be represented—might

CANALETTO • *Ruins of a Courtyard* • pen and ink with gray washes over light pencil sketch, 293 x 207 m
Chicago, The Art Institute, The Samuel P. Avery Fun

be drawn in a separate study from a dummy. One of the interesting features of many such studies is the noticeable alteration of the pose drawn over or alongside the original version. These were, after all, working drawings—only a means to a larger end; thus no erasure was required.

Such evidence of changes of mind or very rough highlighting may occasionally be seen, as in Plate 85 by Pietro da Cortona. In the High and later Renaissance when some of the older workshop practices and studio rules were passed over, there were mixtures of methods and of materials. The study by Sebastiano del Piombo (Plate 51) is a black-chalk figure drawing, done in the normal medium, but it has been elaborated with opaque liquid white (gouache). Later, but in the period covered by this book, natural black chalk (a carboniferous soft slate cut into sticks) gave way to crayons compressed from ground-up chalk or charcoal with a binder. Red chalk or hematite also eventually was ground and compressed into crayons. Red was not often used by artists until just before 1500, but not long after that red and black began to be used together. Signorelli (Plate 9) is an early example of this usage. Other examples of detail studies are Bassano (Plate 79), the Agostino Carracci (Plate 86), and the Michelangelo (Plate 69), the Mainardi (Plate 39), the Gozzoli (Plate 8), and Andrea del Sarto (Plate 63). Sometimes, as in Plate 64 by Perugino, silverpoint was used for a detail study.

It is not always easy to decide whether portrait studies were made for incorporation into large compositions, for individual painted portraits or for their own sake. From their attitudes, one may safely guess, however, that Plate 27 by Vivarini, and Plate 50 by Lotto are studies for larger compositions. The Antonella da Messina (Plate 31) was probably done in preparation for a painted portrait. Apparently drawn independently were the Annibale Carracci (Plate 74) and the Piazzetta (Plate 92).

Landscape drawings were rarely studies for paintings. Once Leonardo established that the structure of landscape was interesting, other artists too

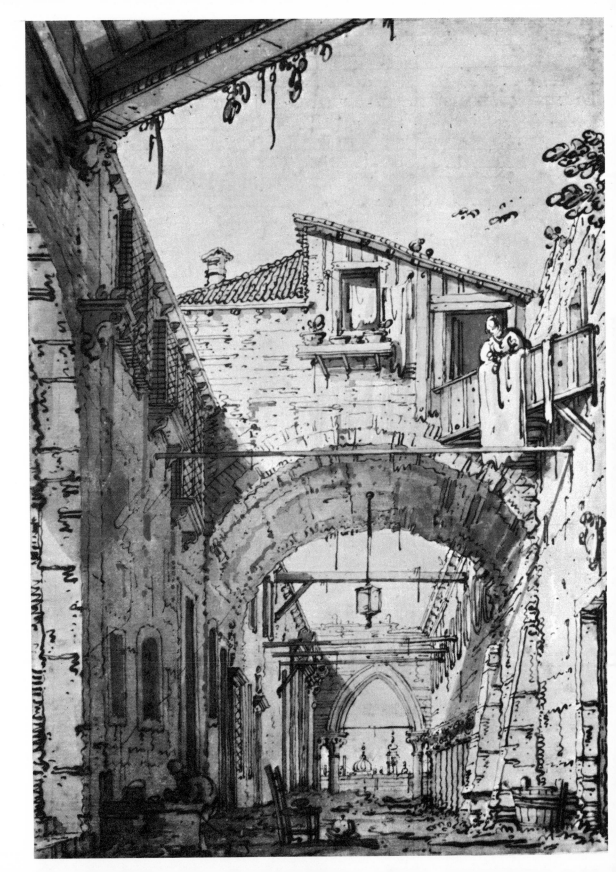

were fascinated by the subject, and landscape drawing was thereafter done for its own sake. In seventeenth century Rome, the French painter Claude Lorraine drew constantly out-of-doors synthesizing the northern and southern attitudes toward landscape. But Italy never felt the same passion as Holland did for landscape drawing.

Such a drawing as Titian (Plate 47) may have been for the background of a painting or for a woodcut or engraving. The Vanvitelli Plate 88 was surely drawn as an object for sale. So also probably were the two drawings by Canaletto (Plate 93, and Figure 5) with their apparently planned oppositions of gray carbon-ink wash to brown acid-ink lines.

When all of the details of a painting were ready and the panel, canvas or wall prepared for the tempera, oil or fresco, the main lines of the composition were laid in—although the Venetians often outlined theirs directly with brush on canvas. Methodical artists used a *cartone* (a big paper, hence the word "cartoon") or full-size pattern to which the principal outlines had been transferred by enlarging from detail studies or smaller compositions. This was done by squaring with a network of ruled lines which allowed copying in correct proportion, square by square. The drawings by Bramante (Plate 5), Titian (Plate 46), Sebastiano del Piombo (Plate 51) and Pontormo (Plate 60) are all on such squared paper.

The cartoon itself might be transferred to panel or canvas by tracing or pouncing. In the case of large paintings a number of smaller drawings had to be pasted together. Pouncing was a process in which a small cloth bag of powdered charcoal or "pounce" was tapped along the main lines of the drawing which had been pricked with closely-spaced holes to allow the powder to pass through. The Raffaellino del Garbo (Plate 40) had been thus pricked, probably for an embroidery design. This method of transfer was preferable for yielding cloth to tracing, for tracing demands a hard surface beneath the paper.

Transferring a design to a wall prepared for fresco painting was done in another manner. Fresco painting must be done on wet plaster. Only enough of the plaster for one day's work could be laid on at a time. The design was drawn with a brush in position, the artist cut through with a knife or stylus, thus getting an incised "drawing" in the wet plaster, and incidentally cutting the drawing to pieces. Hence, few fresco cartoons have been preserved. The nearest to one represented in this volume is a Correggio (Plate 72), which has the scale and character of a cartoon detail.

Finally we must add to the independent drawings those works of Guercino (Plate 82) and the two Tiepolos (Plate 90, 91) which were equally important with painting in the body of their work. The younger Tiepolo made drawings for sale as independent works of art as Canaletto had done. Guardi's *Romantic Capriccio* (Plate 94) was one of a series of *Capricci* which, although they often served as preliminary painting studies, were often independent drawings. Some of Piranesi's architectural fantasies did not appear as engravings, theater designs or buildings. In fact, Venice produced a rich store of drawings *as drawing* that makes a strong conclusion to the selection of Italian drawings included in this volume.

Winslow Ames

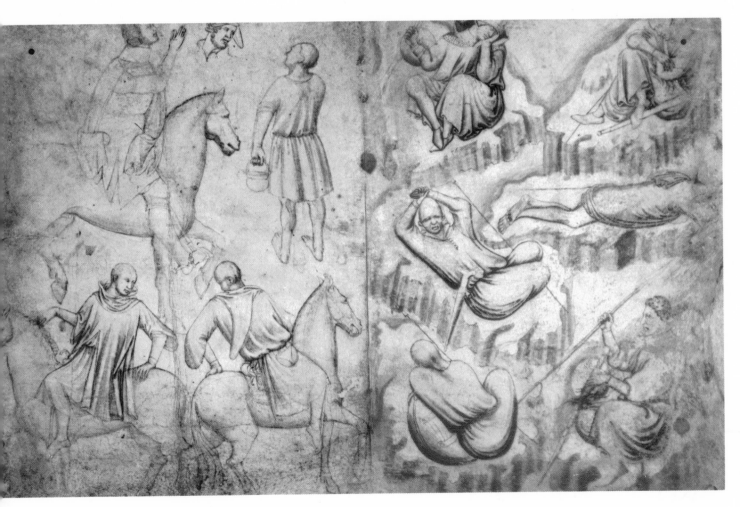

Plate 1

ALTICHIERO da Zevio · *Album Folio* · pen and ink with gray and brown washes on parchment, 220 x 345 mm.
Bayonne, Musée Bonnat

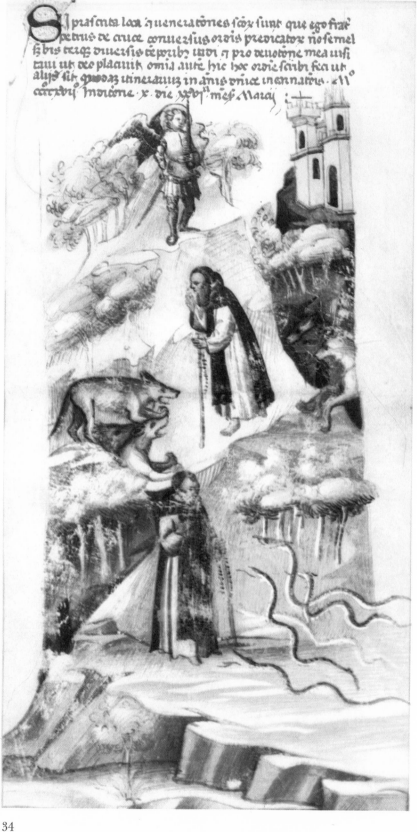

Plate 2

ITALIAN, Tuscan 15th Century
*Incidents of a Pilgrimage to Jerusalem*
pen and ink with water color washes on
vellum, 254 x 136 mm.
Cambridge, Mass., Harvard University
Fogg Art Museum

34

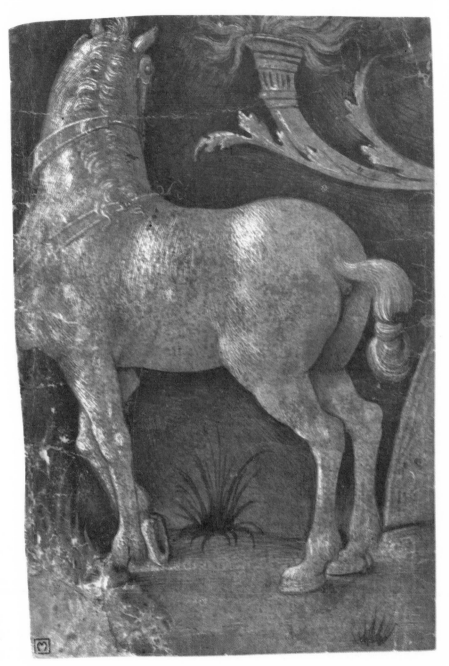

Plate 3
ITALIAN, Florentine 15th Century
*Study of a Horse*
brush and bistre, heightened with white
on terra verde ground, 120 x 175 mm.
Princeton, New Jersey
Princeton University, The Art Museum

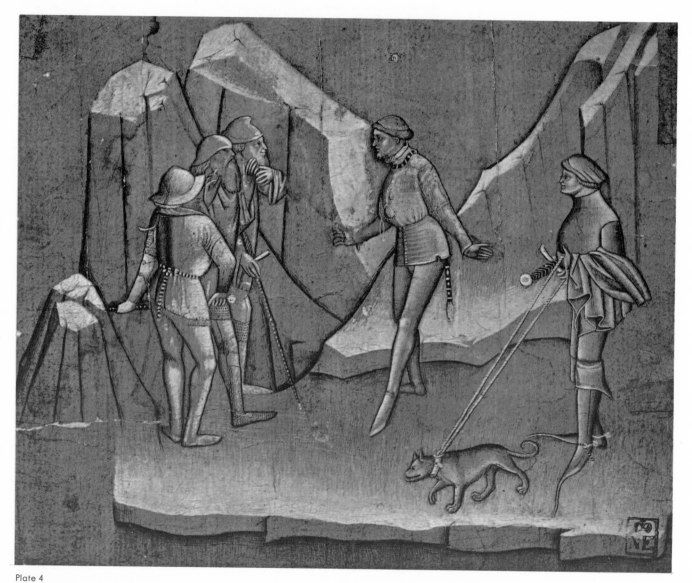

Plate 4

ITALIAN, Lombard Early 15th Century · *Hunting (?) Scene* · pen and black ink, heightened with white on blue-green ground,
148 x 182 mm. · Budapest, Museum of Fine Arts

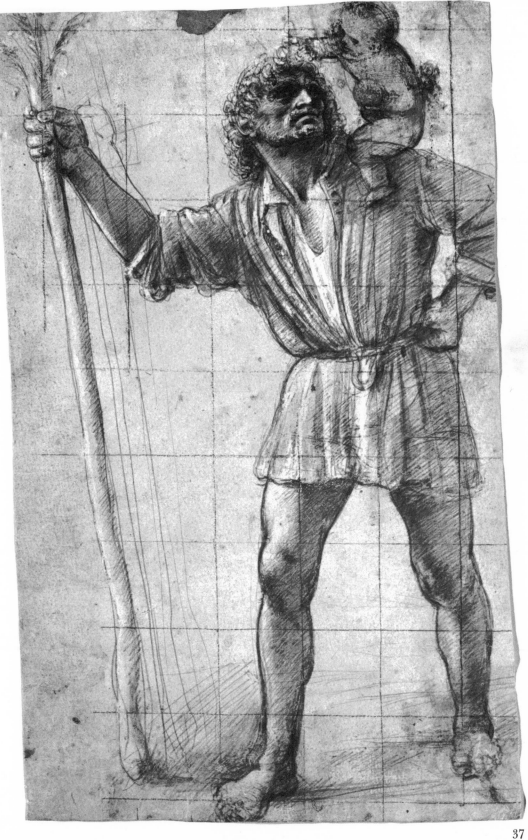

Plate 5

BRAMANTE
*Saint Christopher*
silverpoint and white heightening on
prepared paper, 308 x 190 mm.
Copenhagen
Royal Museum of Fine Arts

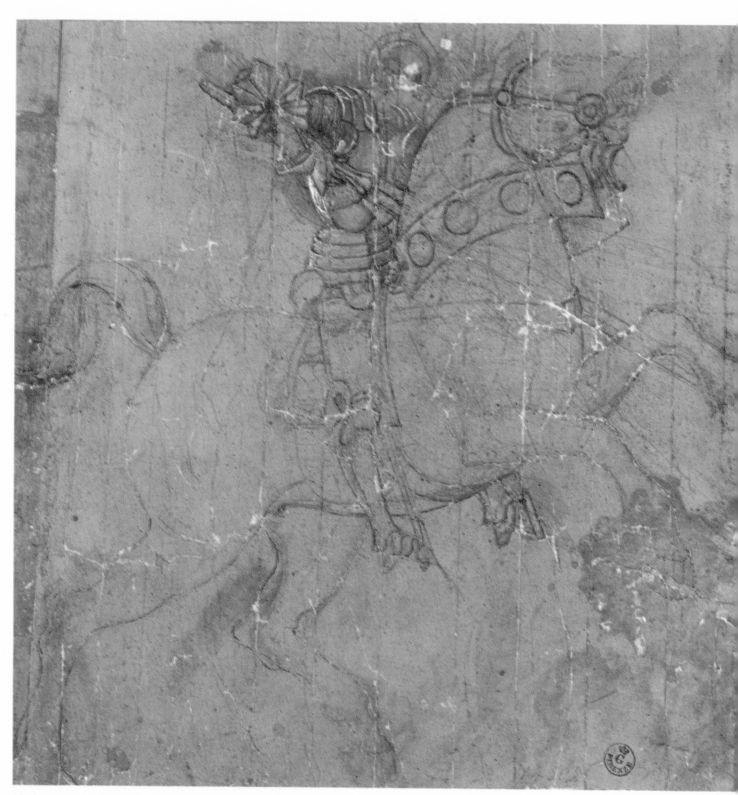

Plate 7

SIGNORELLI
*A Male Nude Stabbing a
Female Nude*
black chalk, heightened with
white, on coarse, light brown
paper, 290 x 201 mm.
London, The British Museum

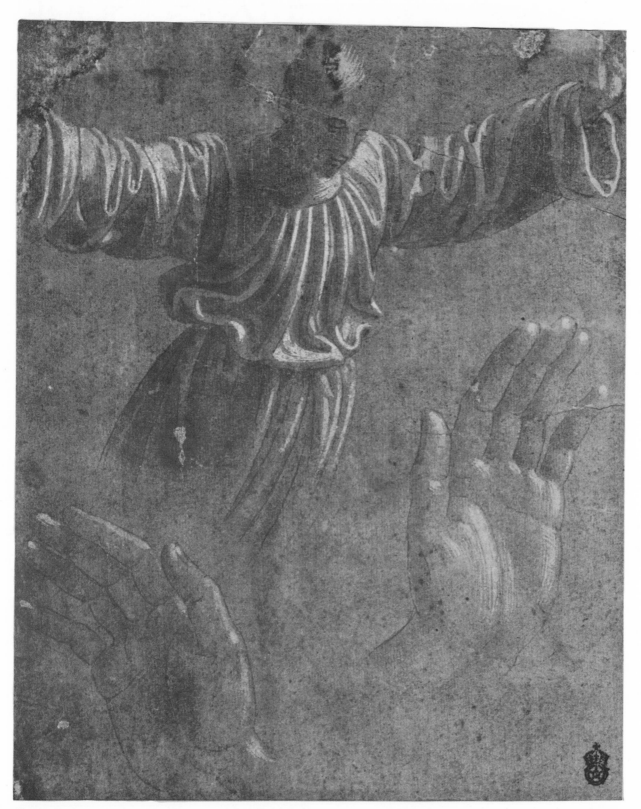

40

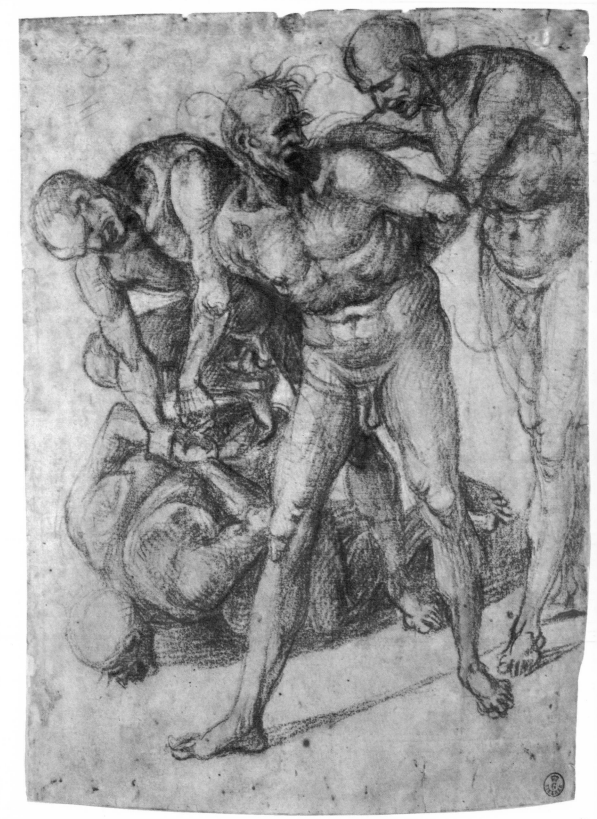

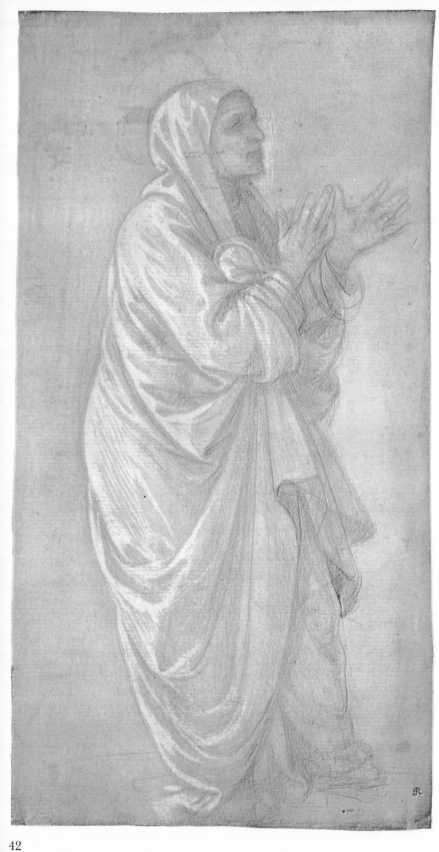

Plate 10

Fra Filippo LIPPI
*A Female Saint Standing*
metalpoint and wash over black chalk on
salmon pink ground, 308 x 164 mm.
London, The British Museum

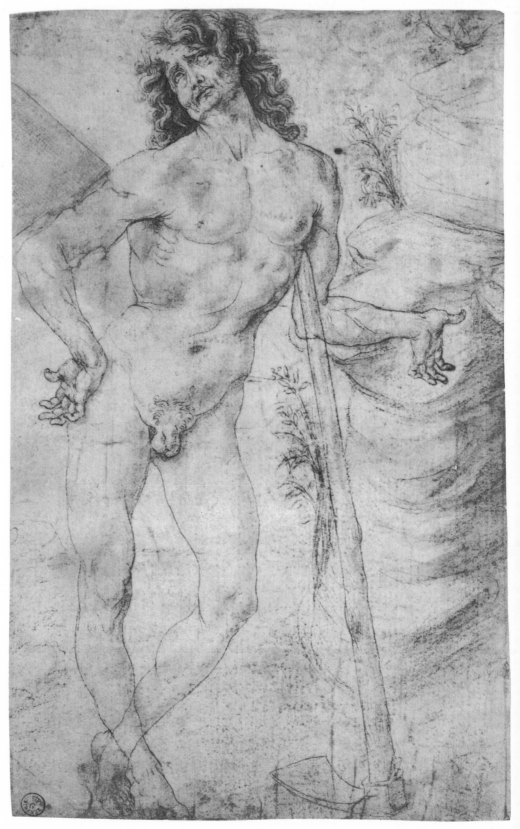

Plate 11
POLLAIUOLO
*Adam*
pen over black chalk, with some
bistre wash, 282 x 180 mm.
Florence, Uffizi Gallery

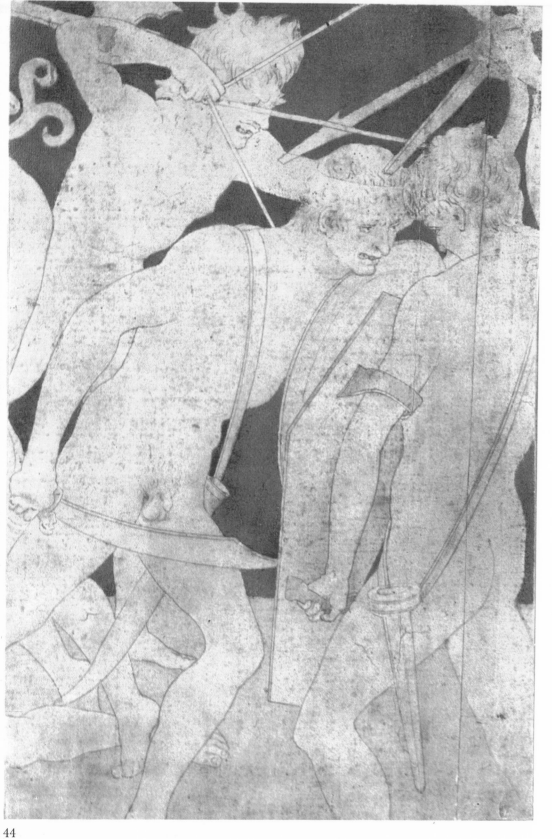

Plate

VERROCCHI

*Head of a Wom*

brush and black ink, heighten

with white, on red grou

267 x 224 m

Paris, Louv

Plate 12

POLLAIUOLO
*Fighting Nudes*
pen and bistre, washed with bistre
270 x 180 mm.
Cambridge, Mass.
Harvard University
Fogg Art Museum
Meta and Paul J. Sachs Collection

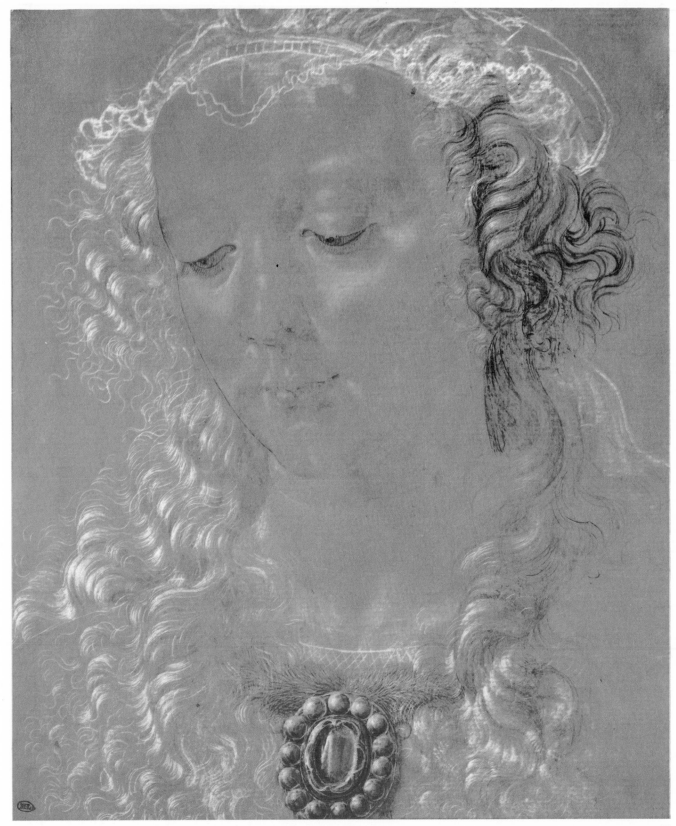

45

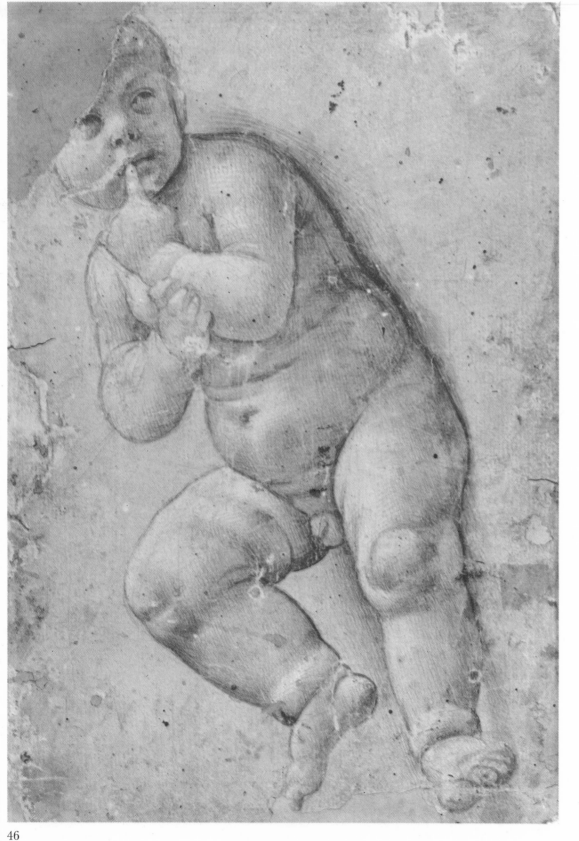

Plate
VERROCCH**
*Head of an Ang*
black chalk, pricked for transf
208 x 180 m
Florence, Uffizi Galle

Plate 14
LORENZO di Credi
*Study for a Christ Child*
silverpoint, heightened with
white, on pinkish prepared pap
175 x 254 mm.
Berlin, Kupferstichkabinett

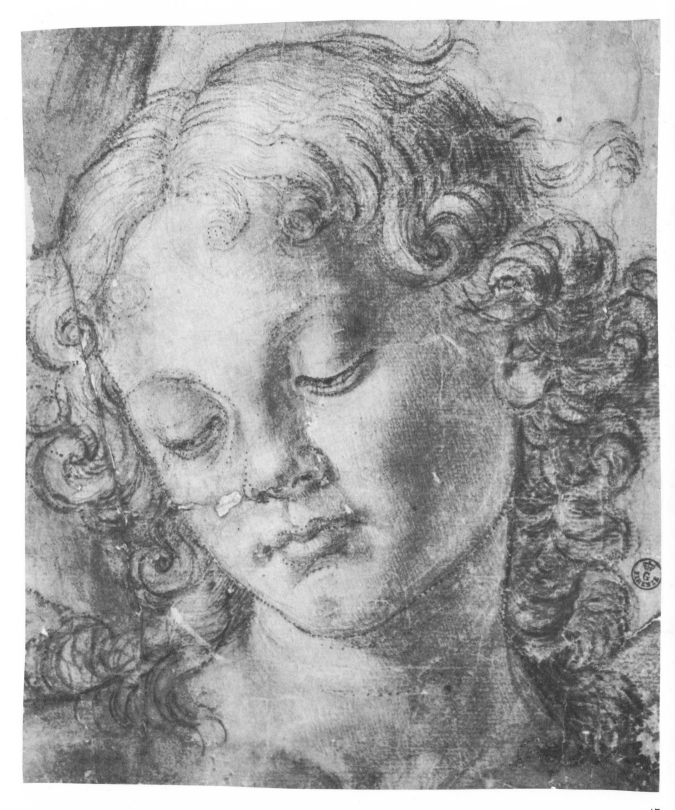

47

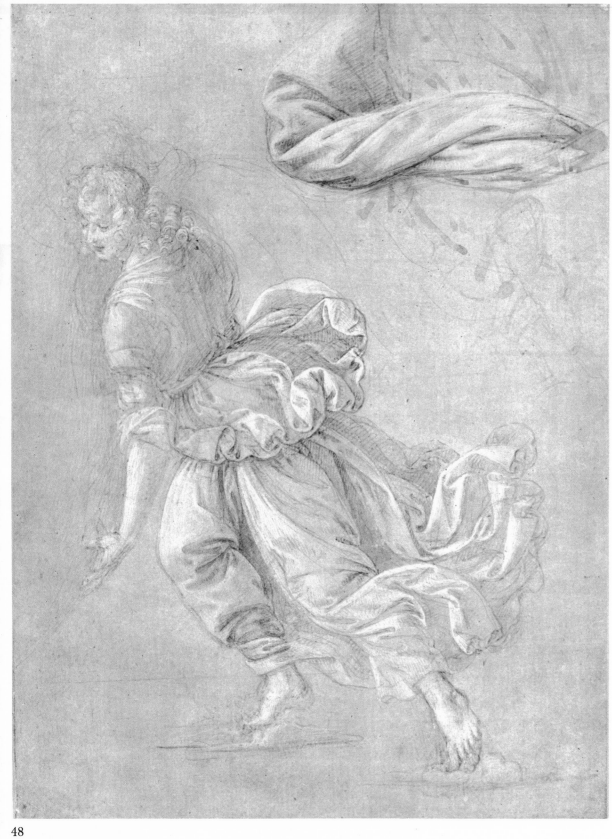

48

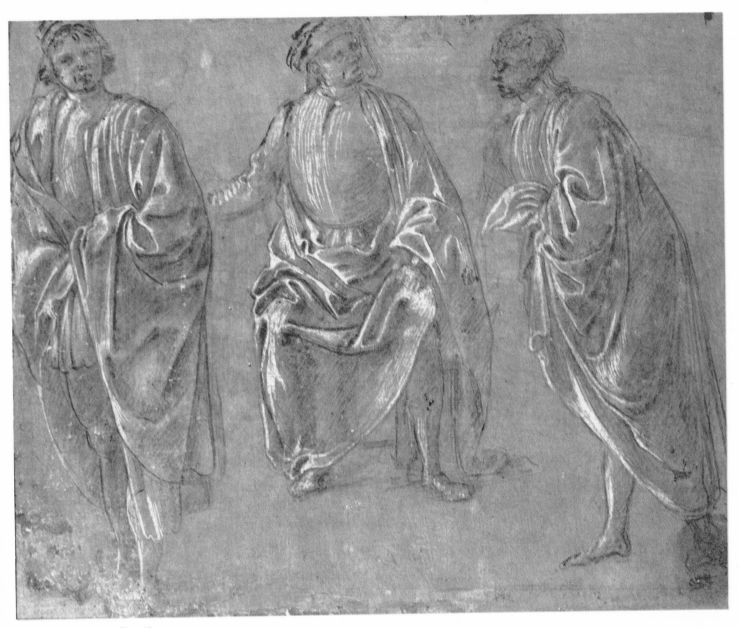

Plate 17

Davide GHIRLANDAIO · *Three Draped Male Figures* · silverpoint, heightened with white, on purple ground, 197 x 243 mm.
Frankfort-on-Main, Staedel Art Institute

Plate 16

LORENZO di Credi · *An Angel Running Toward the Left; Study of Drapery*
metalpoint and ink with brown wash on mauve pink paper, heightehed with white, 243 x 182 mm.
London, The British Museum

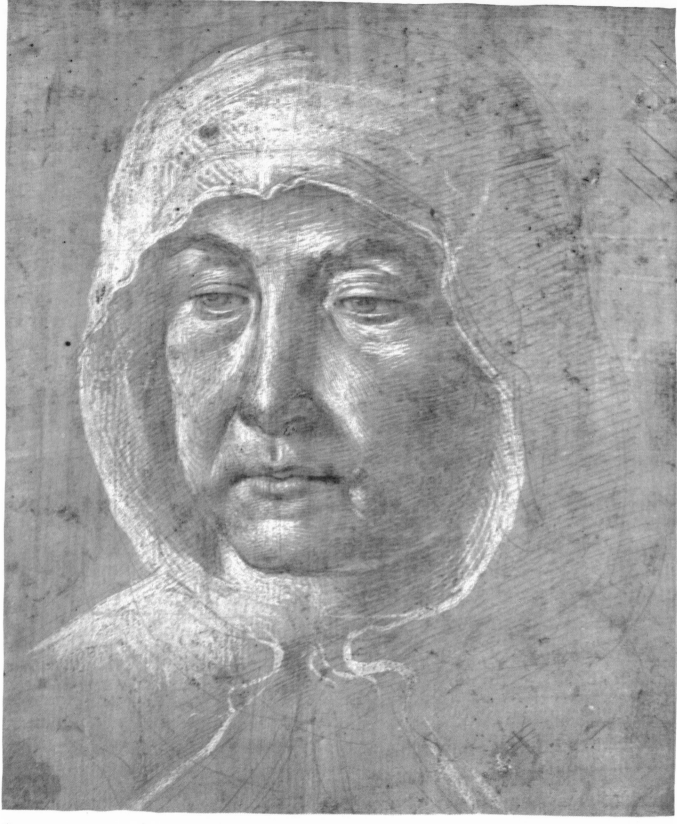

te 18

menico GHIRLANDAIO
ad of an Old Woman
alpoint, heightened with white, on
nge ground, 232 x 185 mm.
ndsor Castle, The Royal Collection

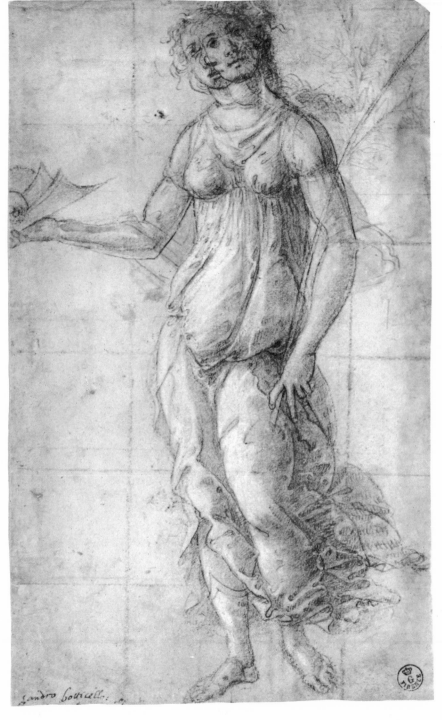

Plate 19
BOTTICELLI (school of) • *Study for a Pallas* • pen over black chalk, heightened with white on pinkish ground, squared for enlargement and pricked for transfer, 215 x 130 mm. • Florence, Uffizi Gallery

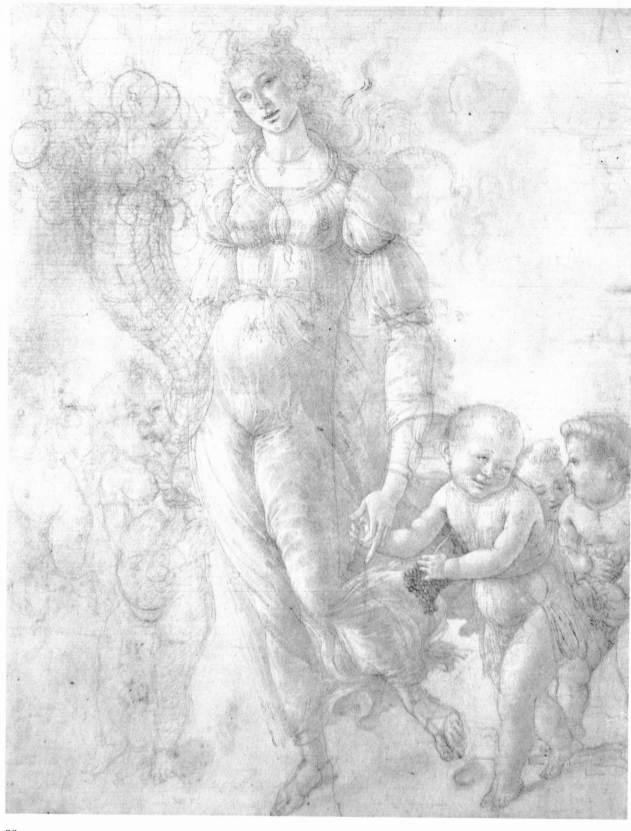

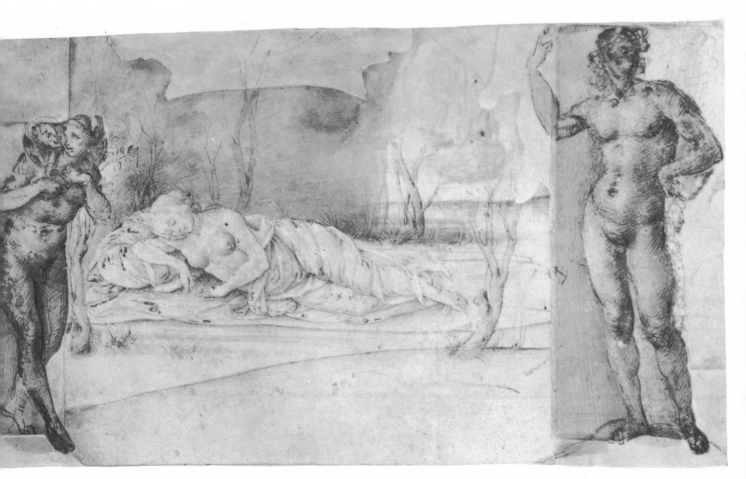

Plate 21

PIERO di Cosimo • *Ariadne (?) Deserted* • pen and wash, heightened with white, mounted on a backing, 141 x 248 mm.
London, The British Museum

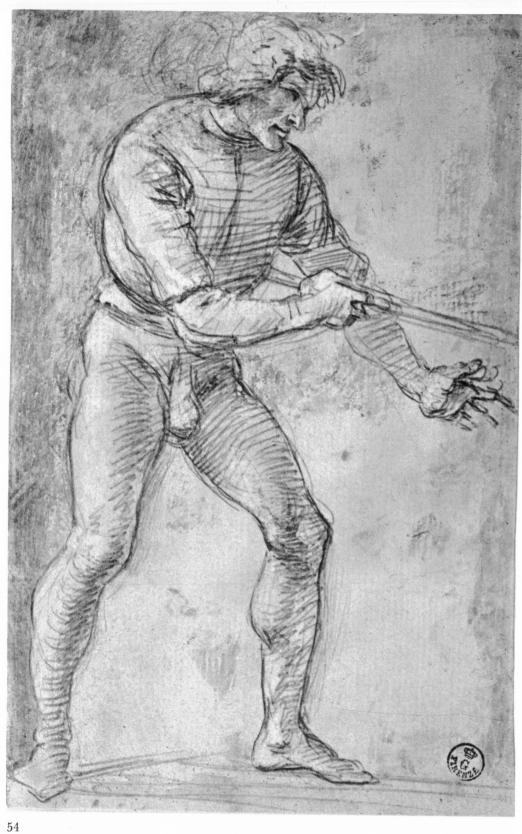

Plate 22

Filippino LIPPI
*Study for a Figure in Action*
black chalk, heightened with
white, on pink ground
180 x 120 mm.
Florence, Uffizi Gallery

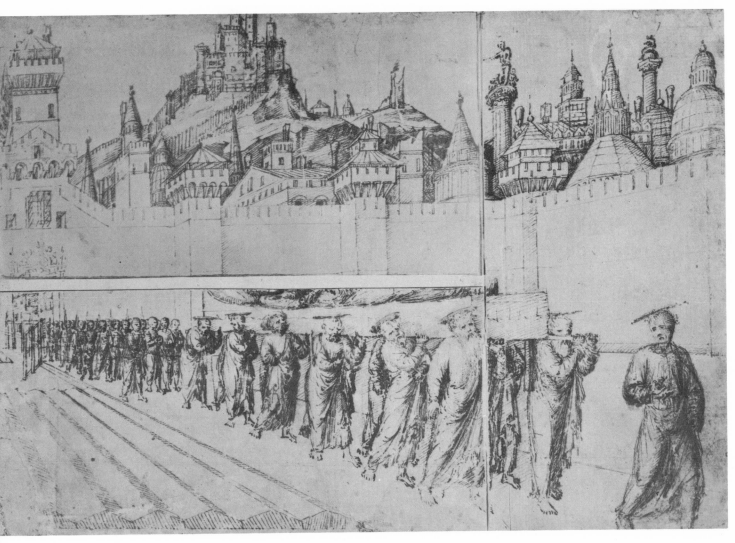

Plate 23

Jacopo BELLINI · *Funeral Procession of the Virgin* · pen and brown ink over black chalk, on paper faded to buff, 210 x 304 mm. Cambridge, Mass., Harvard University, Fogg Art Museum

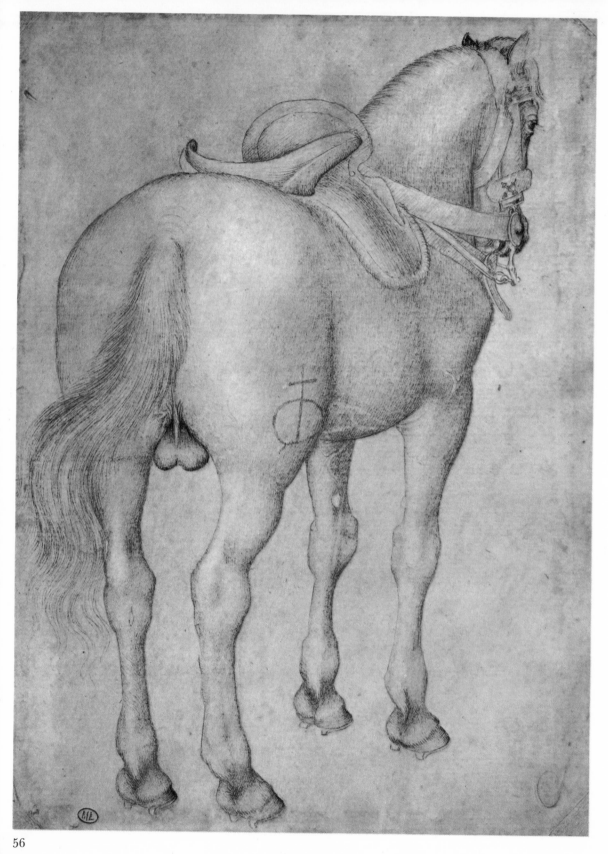

Plate 24

PISANELLO
*A Saddled Stallion*
pen and ink on white pap
223 x 166 mm.
Paris, Louvre

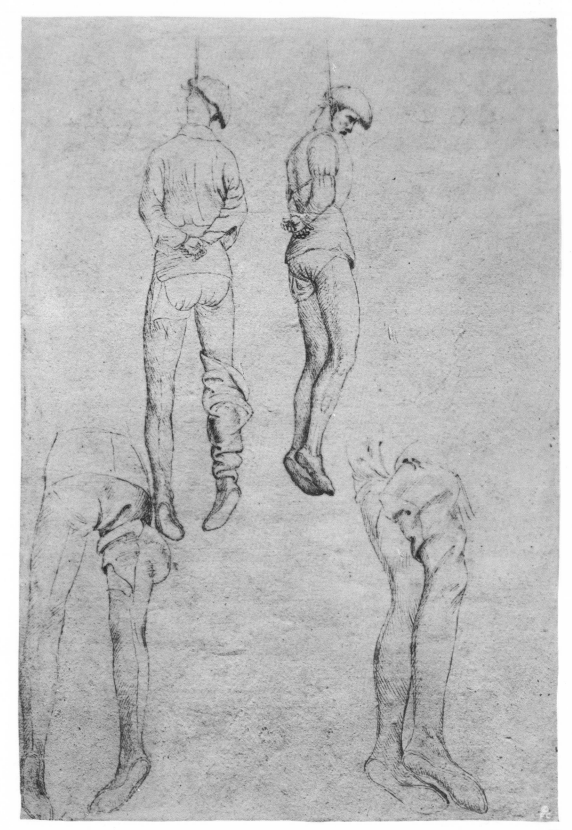

Plate 25
PISANELLO
*Studies of Men Hanging
on the Gallows*
pen and ink, 260 x 175 mm.
New York, The Frick Collection

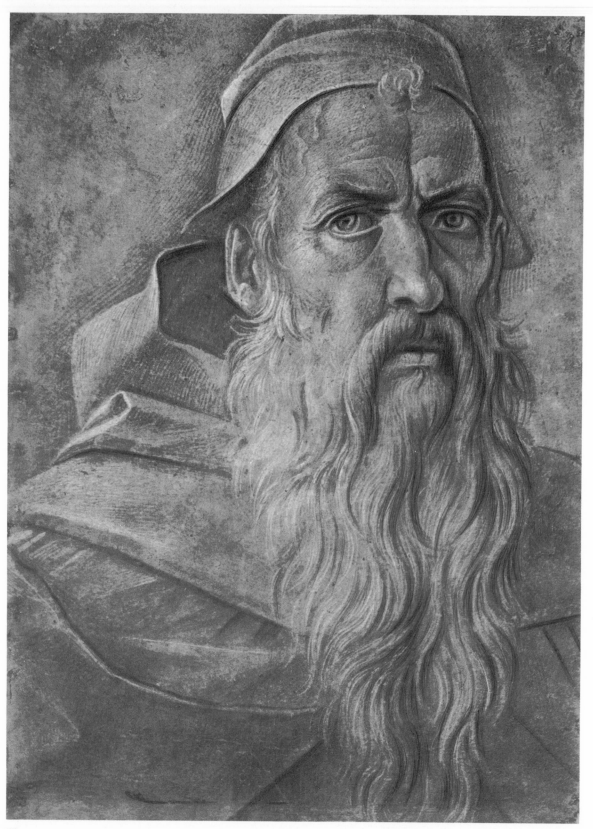

Plate 26

Giovanni BELLINI
*Head of an Old Man*
point of the brush on
blue paper, heightened w
white, 260 x 190 mm.
Windsor Castle
The Royal Collection

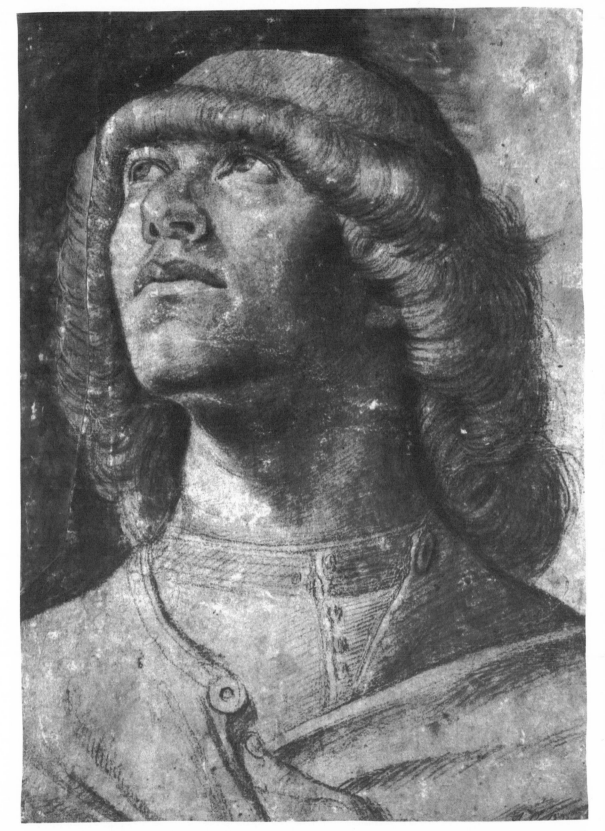

Plate 27
VIVARINI
*Portrait of a Man
Wearing a Cap*
charcoal on grayish-brown
paper, 354 x 255 mm.
Frankfort-on-Main
Staedel Art Institute

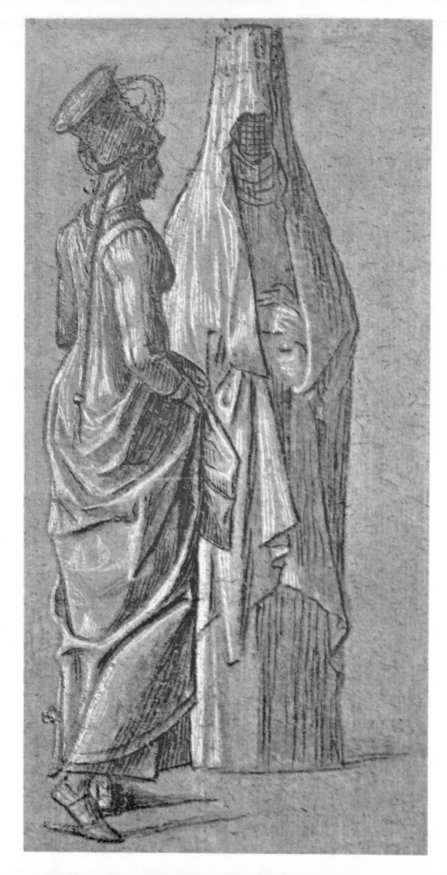

Plate 28

CARPACCIO
*Two Turkish Women*
black and white chalk on brown paper
224 x 112 mm.
Princeton, New Jersey
Princeton University, The Art Museum

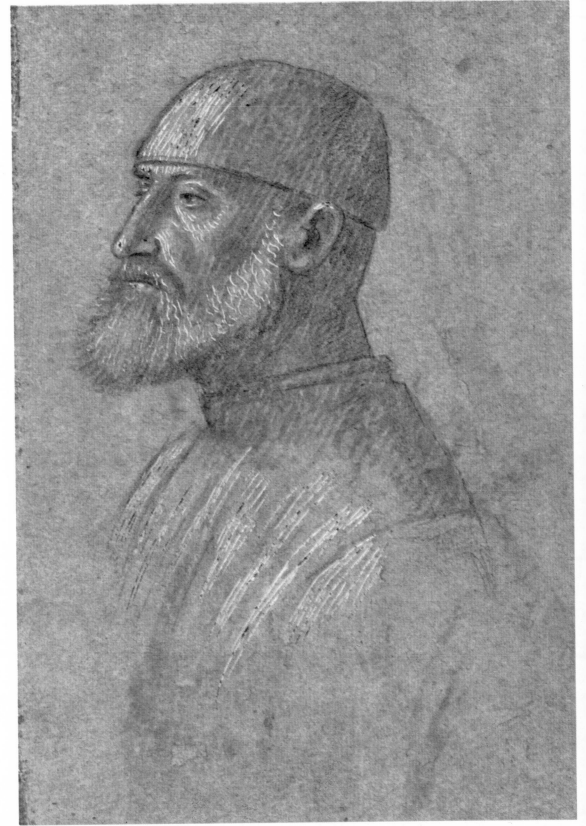

Plate 29

CARPACCIO
*Head of a Bearded Man
Wearing a Cap*
brush and brown wash,
heightened with white, some
black chalk, on blue paper
265 x 186 mm.
New York
The Pierpont Morgan Library

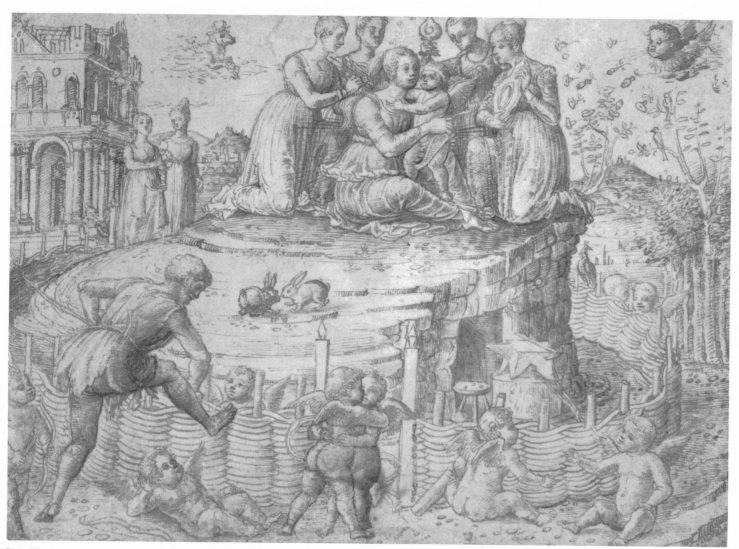

Plate 30

FRANCESCO del Cossa (school of) • *Venus Embracing Cupid at the Forge of Vulcan* • pen and ink
280 x 398 mm. • New York, The Lehman Collection

Plate 31

ANTONELLO da Messina • *Portrait of a Boy* • black chalk, 330 x 269 mm. • Vienna, Albertina Gallery

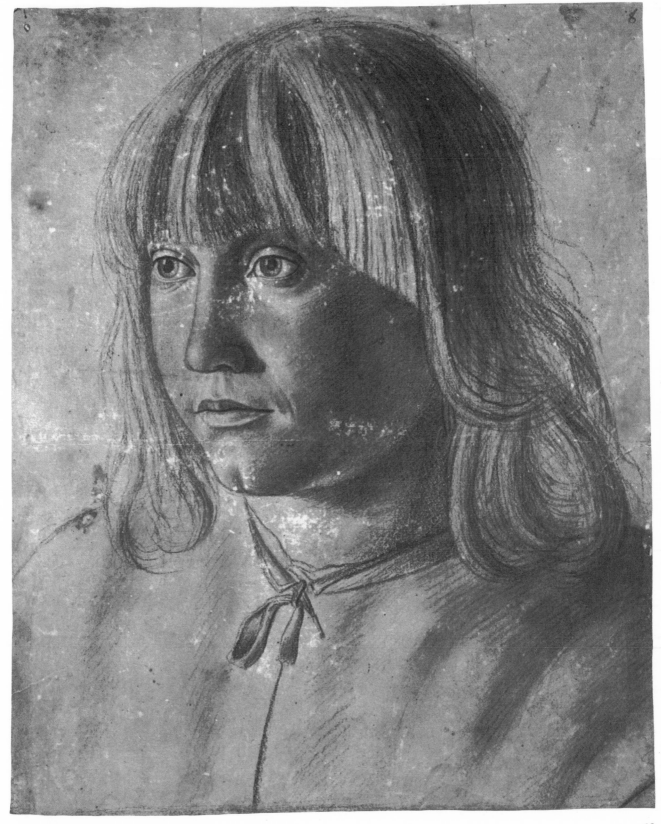

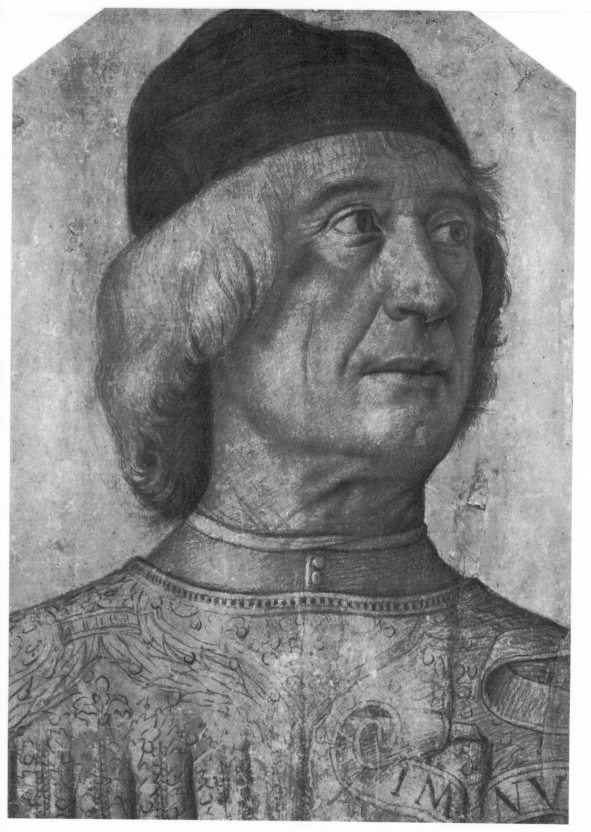

Plate

MANTEGN
*Mars, Venus (?) and Dia*
pen and wash with touches
white heightening, blue an
red water color and gouach
364 x 317 m
London, The British Museu

Plate 32

MANTEGNA
*Head of a Man*
black chalk, with some wash,
on yellowish paper
392 x 280 mm.
Oxford, Christ Church
Reproduced by permission of
The Governing Body
of Christ Church, Oxford

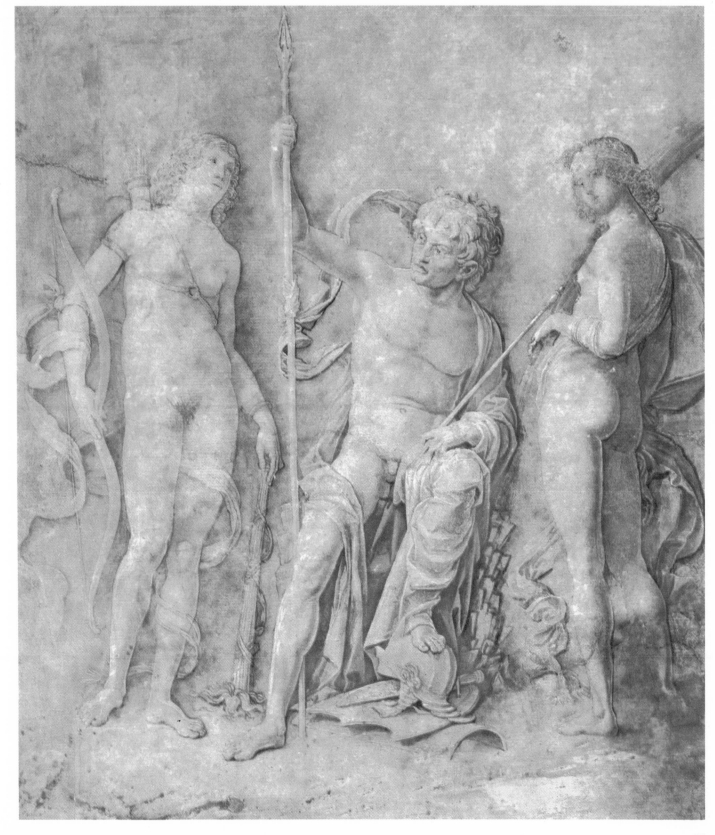

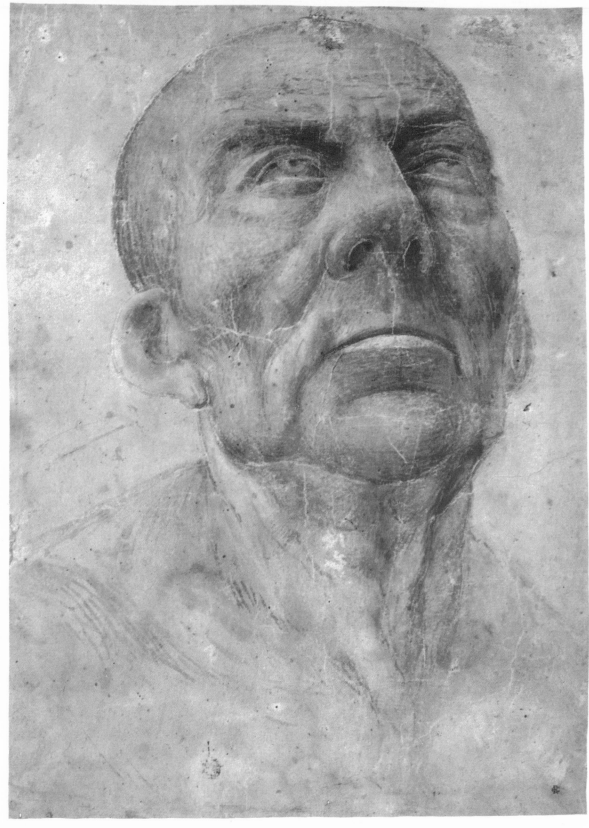

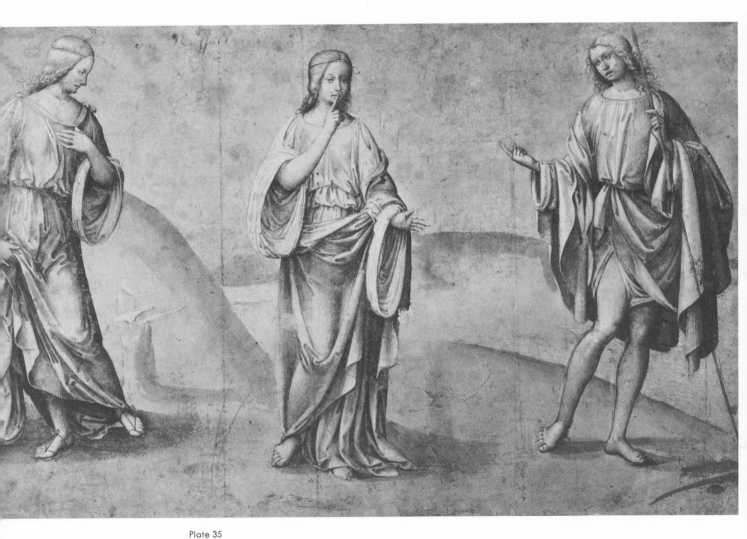

Plate 35

FRANCIA · *Composition of Three Figures* · brush and ink, heightened with white, on tan paper, 224 x 367 mm.
Oxford, Ashmolean Museum

late 34

*ELLEGRINO da San Daniele · *Head of an Old Man* · brush in brown on prepared light brown ground
faded), 319 x 234 mm. · Berlin, Kupferstichkabinett

67

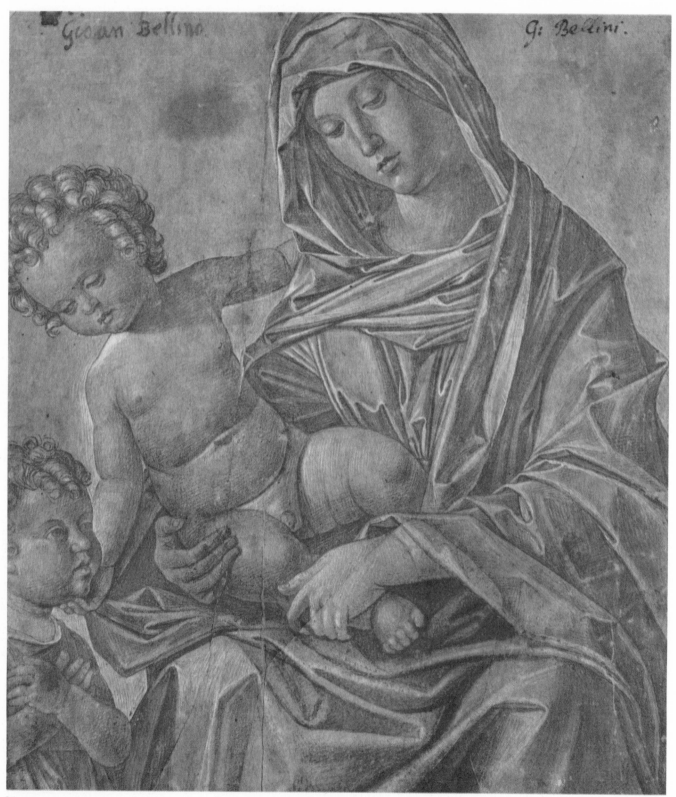

Gioan Bellino.          G: Bellini.

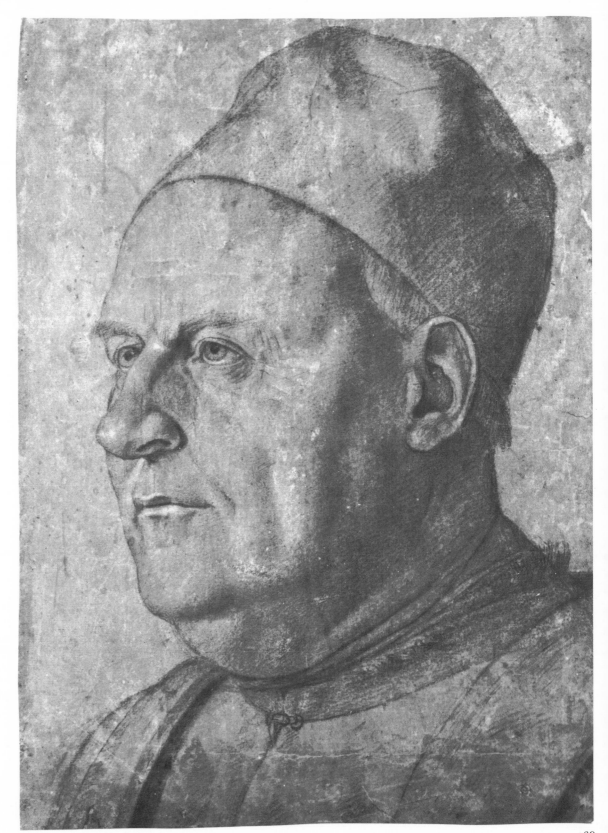

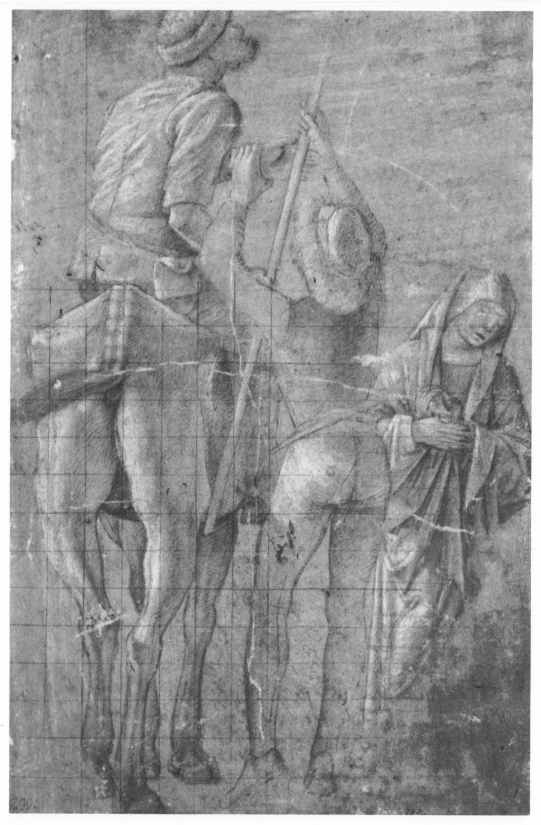

Plate 38
ERCOLE di Roberti
*Study for Spectators in a Crucifixion*
pen and ink, heightened with white,
on gray-brown ground, squared for
enlargement, 240 x 162 mm.
Munich, Staatliche
Graphische Sammlung

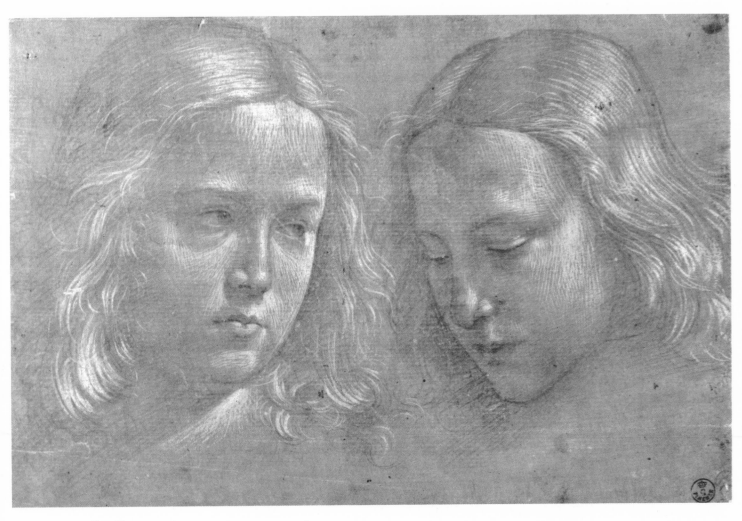

Plate 39

MAINARDI · *Angels' Heads* · silverpoint, heightened with white, on orange-red ground, 170 x 255 mm. · Florence, Uffizi Gallery

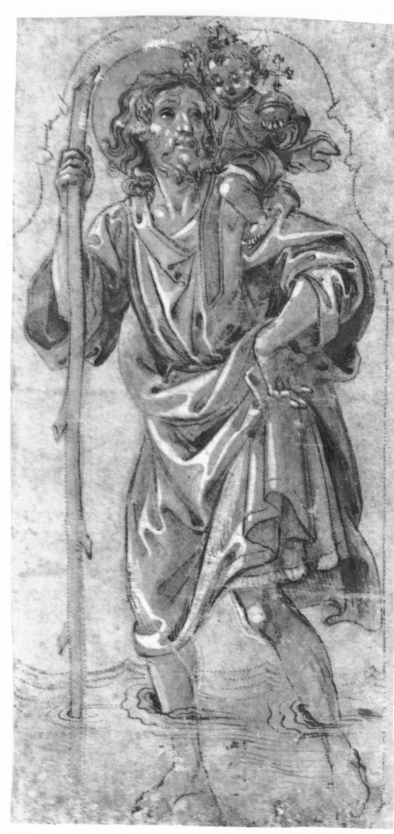

Plate 40

RAFFAELLINO del Garbo
*Saint Christopher*
pen and wash, heightened with
white, on blue prepared ground
225 x 110 mm.
Rome, Gabinetto Nazionale
delle Stampe

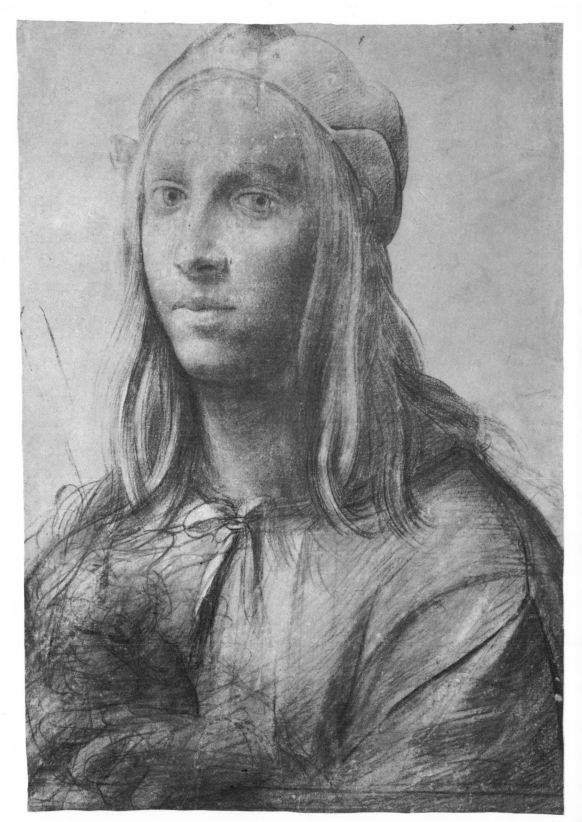

Plate 41
SODOMA
*Portrait, supposed to be that
of Raphael*
black and white chalk
400 x 285 mm.
Oxford, Christ Church
Reproduced by permission of
The Governing Body of
Christ Church, Oxford

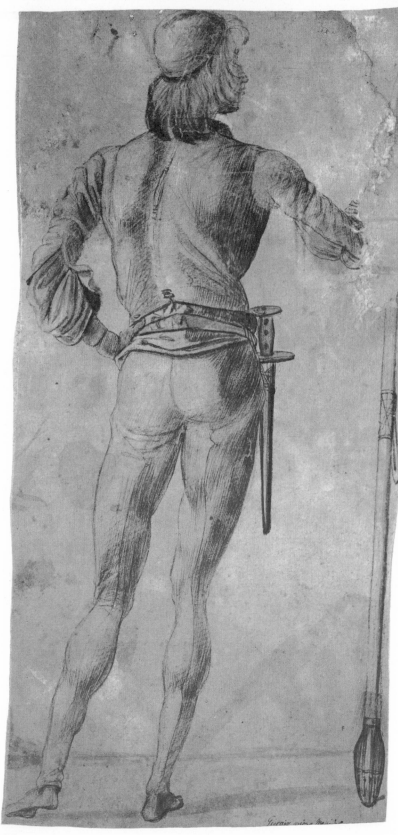

Plate

GIORGIONE
*The Adoration of the Shepher*
brush and bistre heightened with wh
over black chalk preparatio
on blue paper, 227 x 194 m
Windsor Castle, The Royal Collecti

Plate 42

ITALIAN
Venetian 16th Century, after Carpaccio
*Young Man, Back Turned*
red and black crayon with touches of wash
381 x 190 mm.
Washington, D.C.
The Corcoran Gallery of Art
The W. A. Clark Collection

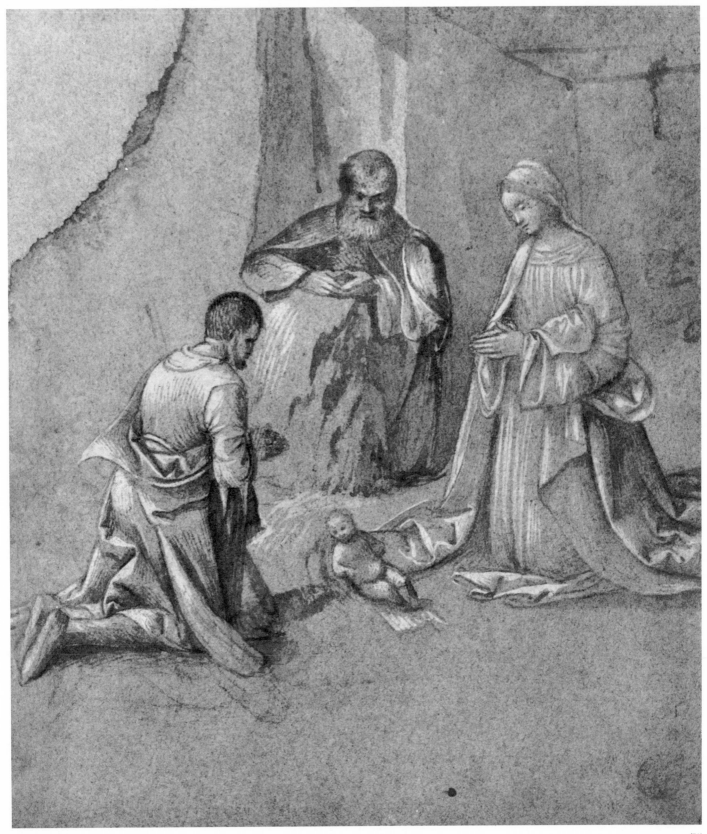

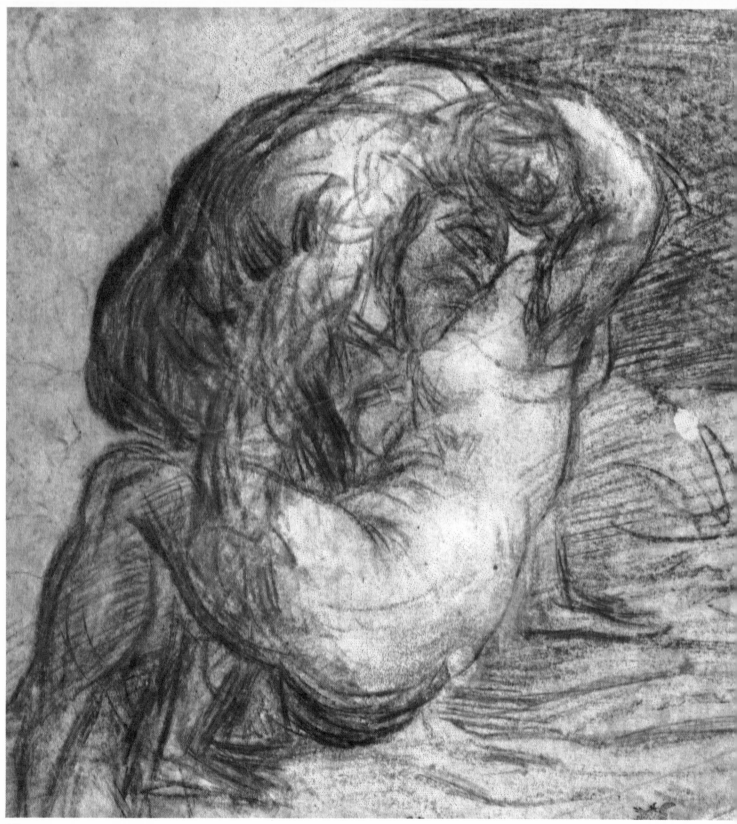

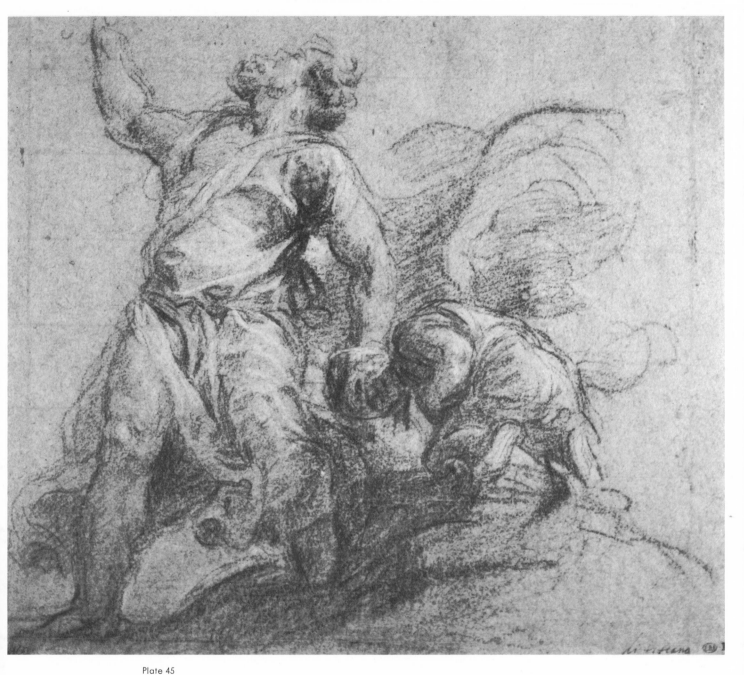

Plate 45

TITIAN · *The Sacrifice of Isaac* · black chalk on gray paper, squared for enlargement in red chalk, 177 x 198 mm. · Paris Ecole Nationale Supérieure des Beaux-Arts

44

N · *Mythological Couple, sometimes called Jupiter and Io*
k chalk on blue paper, 252 x 260 mm. · Cambridge, Fitzwilliam Museum
oduced by permission of the Syndics of the Fitzwilliam Museum, Cambridge

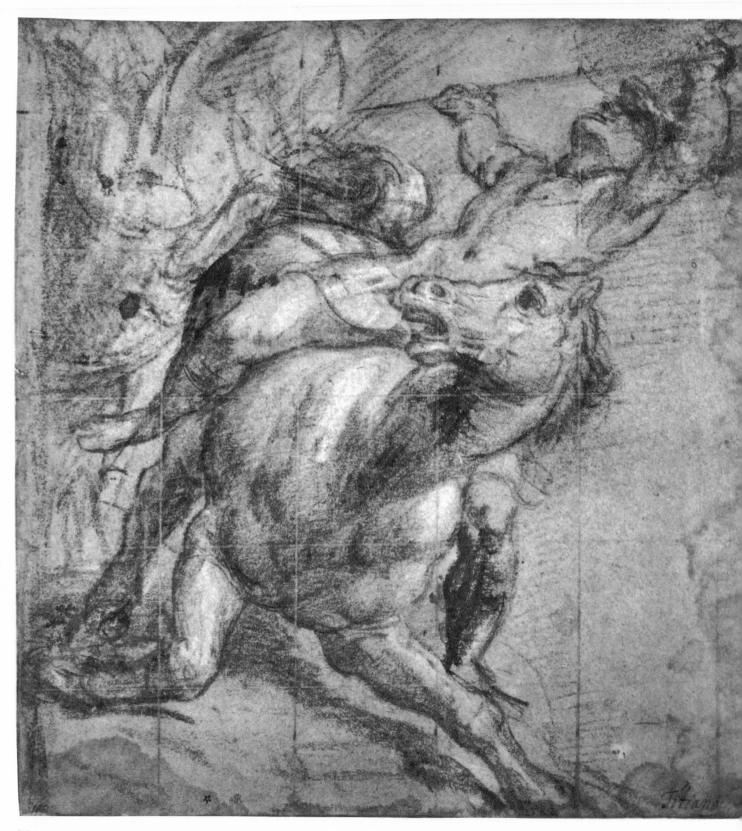

Titiano

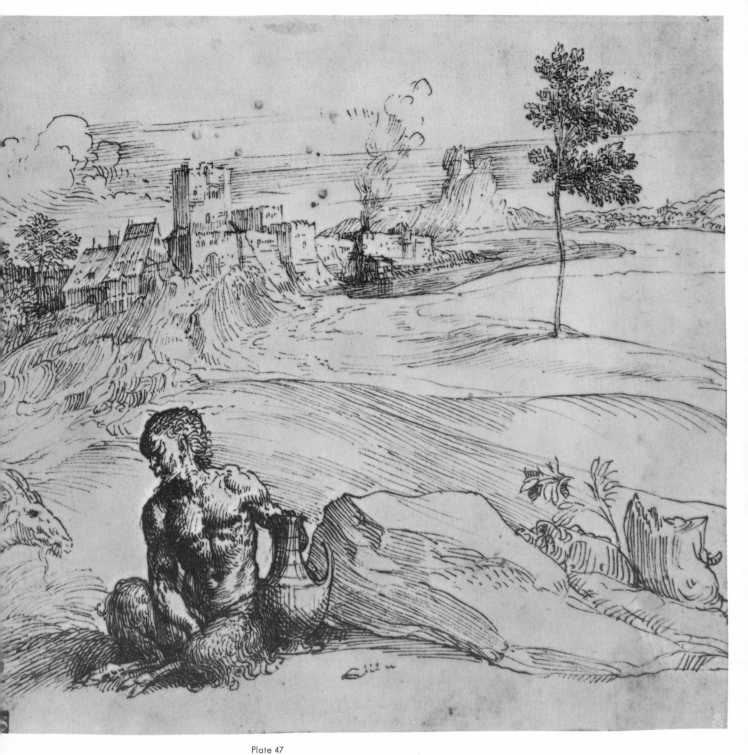

Plate 47

TITIAN · *Landscape with a Satyr* · pen and ink, 186 x 205 mm. · New York, The Frick Collection

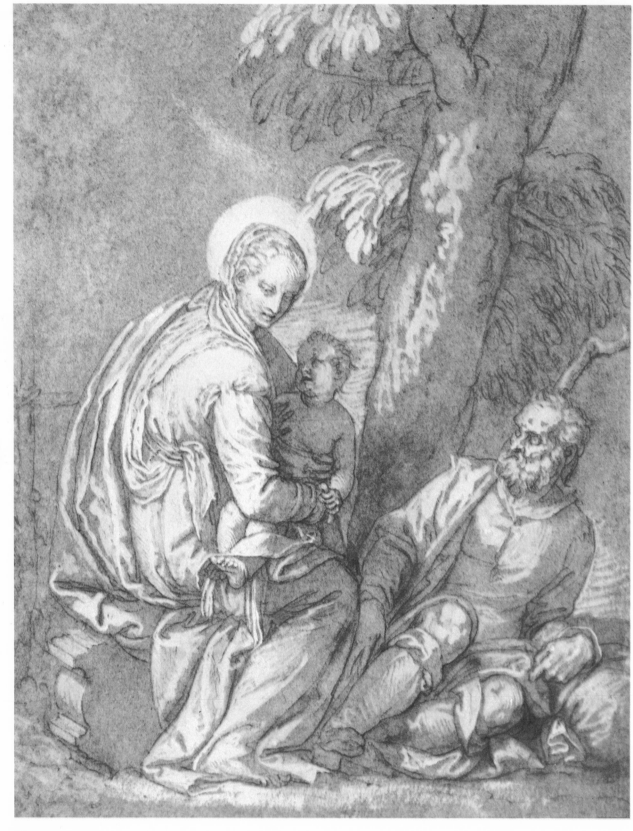

ate 48

ERONESE
e *Rest on the Flight to Egypt*
uill pen and bistre heightened with white on grayish
ue-green paper, 248 x 198 mm.
ambridge, Mass., Harvard University, Fogg Art Museum
eta and Paul J. Sachs Collection

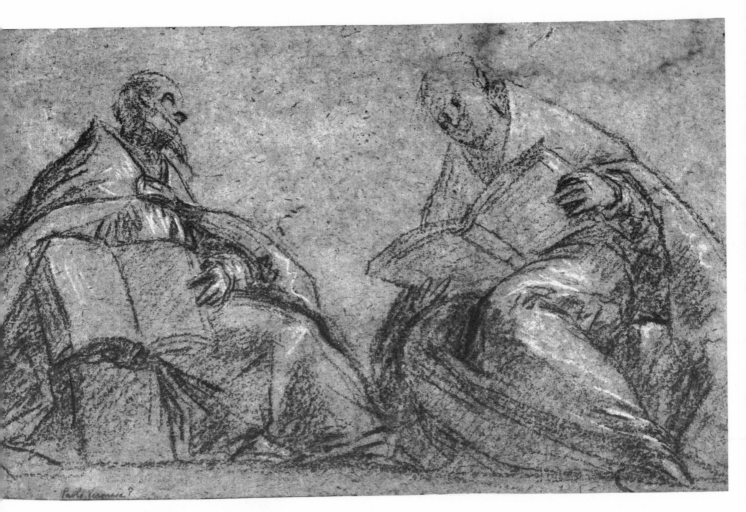

Plate 49

PALMA Giovane · *Two Fathers of the Church* · black chalk, heightened with white, on brownish paper, 237 x 427 mm.
Vienna, Albertina Gallery

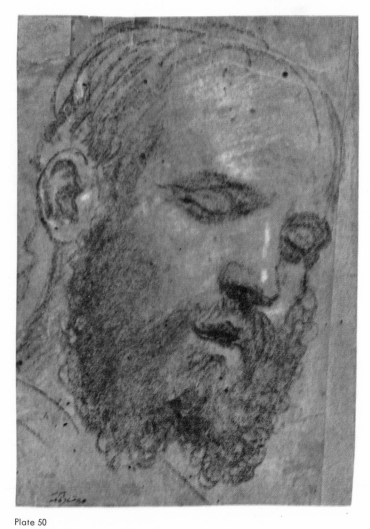

Plate 50

LOTTO · *Head of a Bearded Man* · black and white chalk on blue paper, 185 x 134 mm.
New York, János Scholz

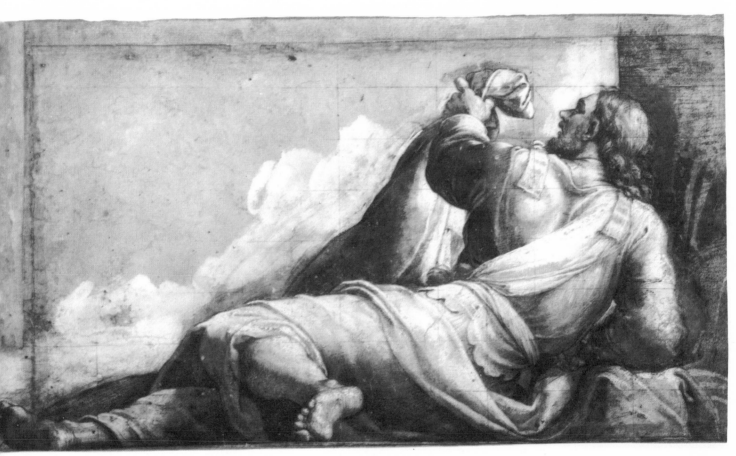

Plate 51

SEBASTIANO del Piombo · Study for an Apostle · black chalk, heightened with liquid white, on greenish paper, squared for enlargement, 235 x 445 mm.

Chatsworth, Devonshire Collection. Reproduced by permission of the Trustees of the Chatsworth Settlement

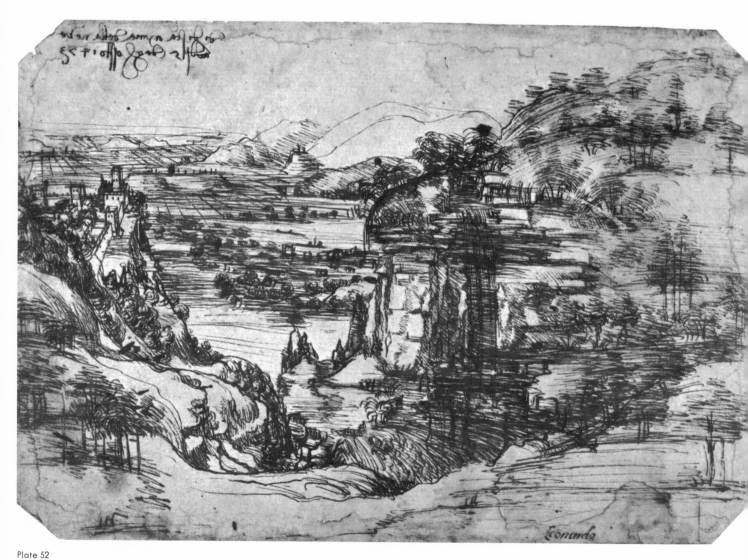

Plate 52

LEONARDO · *Mountain Landscape* · pen and brown ink, 193 x 285 mm · Florence, Uffizi Gallery

84

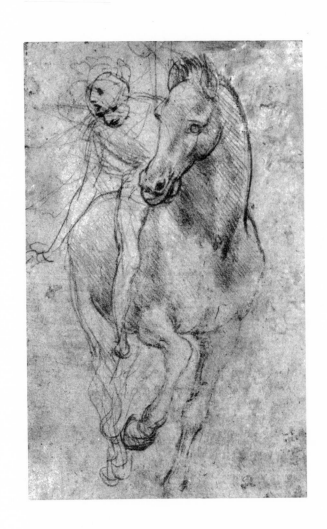

Plate 53

LEONARDO
*Horse and Rider*
silverpoint on white prepared paper
121 x 79 mm.
Newport, Rhode Island
John Nicholas Brown

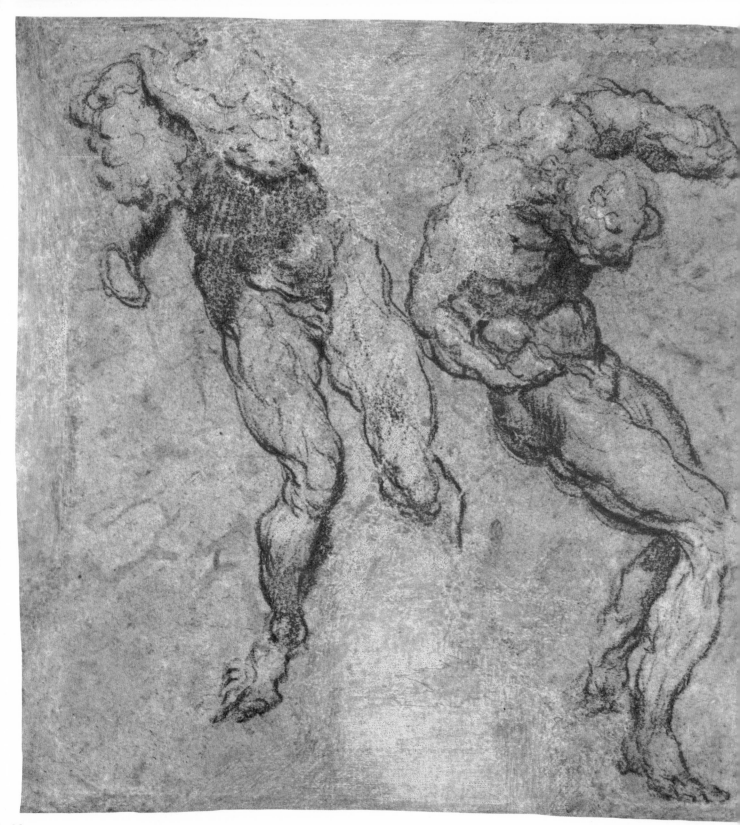

86

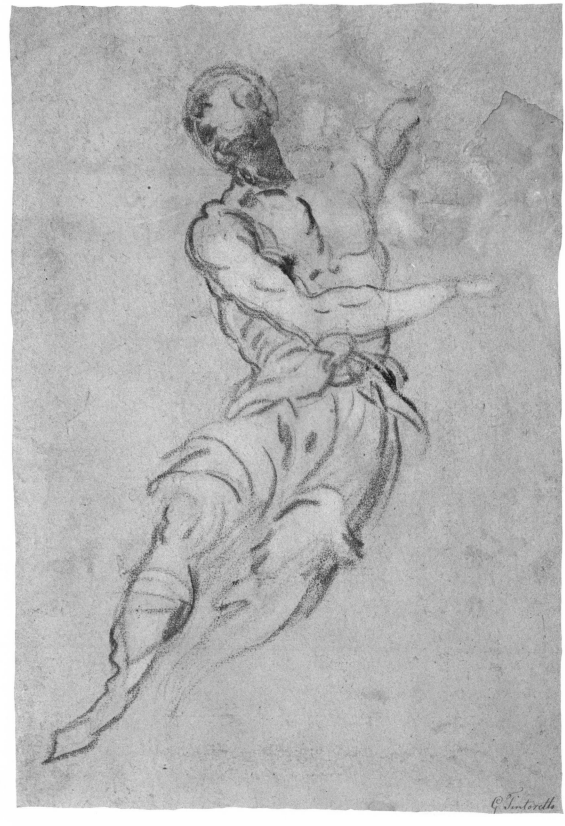

Plate 54

TINTORETTO
*Studies from a Statuette*
black and white chalk on blue
paper, 276 x 272 mm.
Budapest, Museum of Fine Arts

Plate 55

TINTORETTO
*Figure Study of a Man*
charcoal on gray-blue paper
314 x 223 mm.
Cambridge, Mass.
Harvard University
Fogg Art Museum

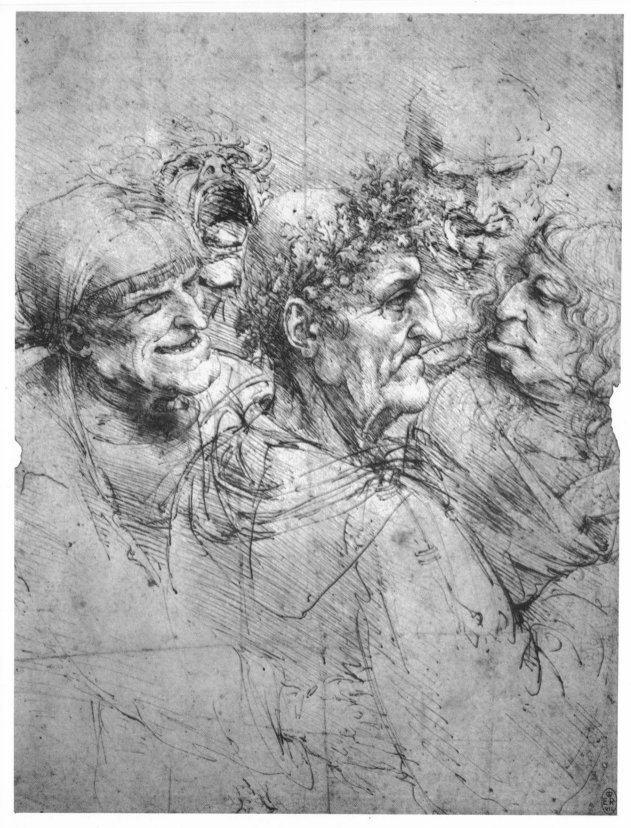

88

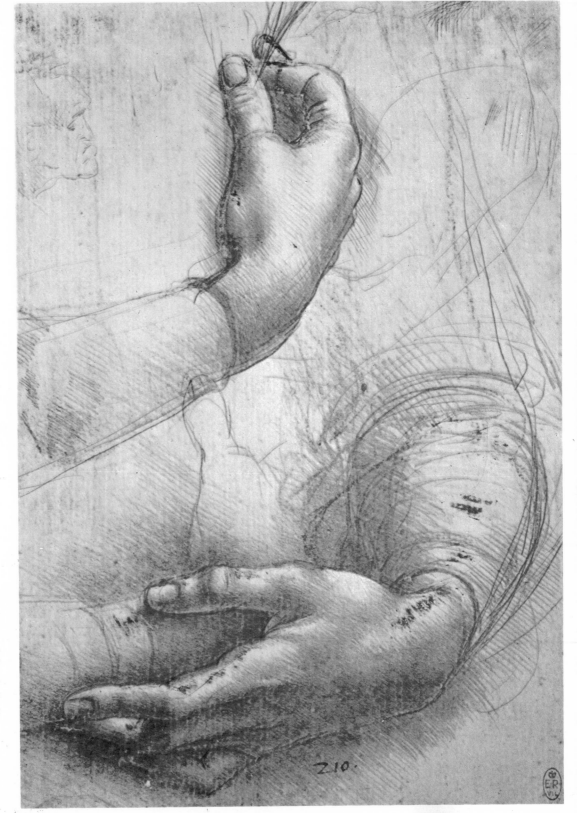

te 56

ONARDO
ve Grotesque Heads
n and ink, 260 x 215 mm.
indsor Castle
e Royal Collection

Plate 57
LEONARDO
*Study of a Woman's Hands*
ilverpoint, heightened with white,
on pink-grounded paper
215 x 150 mm.
Windsor Castle
The Royal Collection

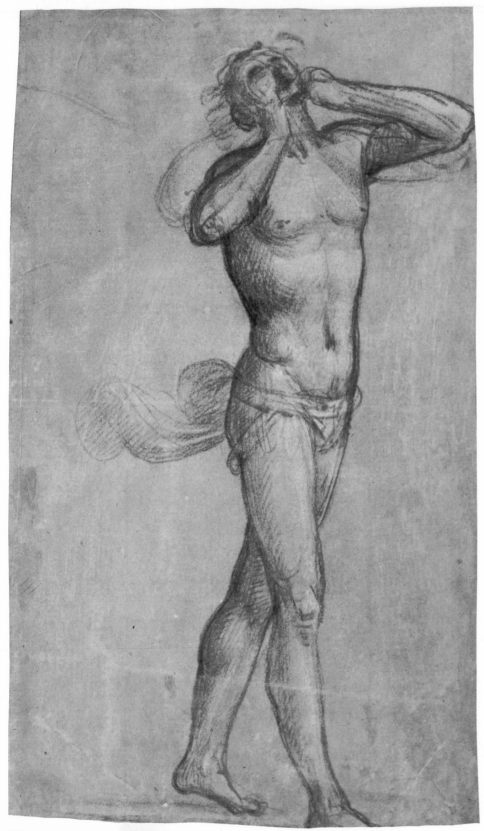

Fra BARTOLOMME
*The Assumption of the Virg*
black and white chalk on brown pap
tinted pink, 220 x 170 m
Milan, Biblioteca Ambrosiar

Plate 58

Fra BARTOLOMMEO
*Study for the Figure of a Damned Man*
black and white chalk on tan ground
290 x 175 mm.
Milan, Biblioteca Ambrosiana

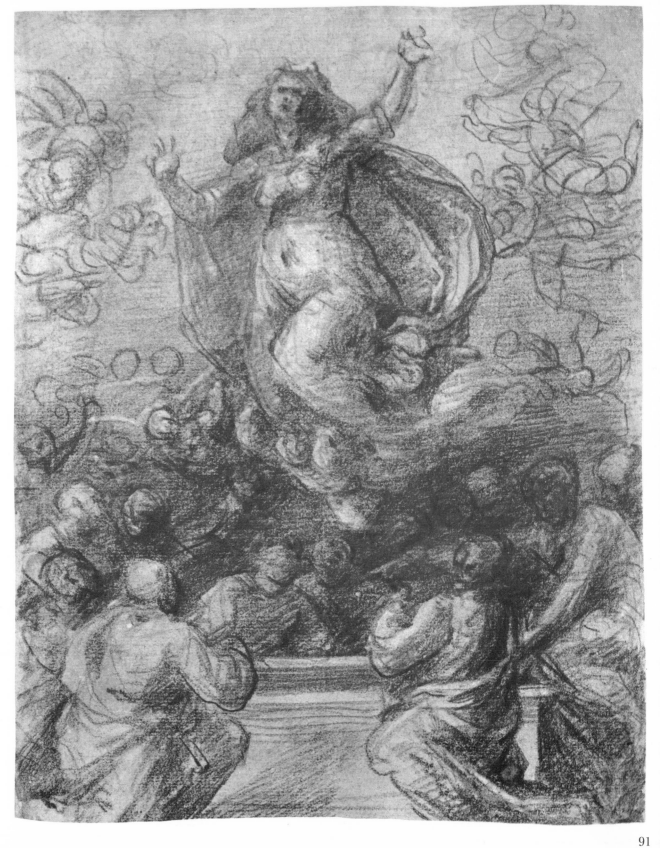

91

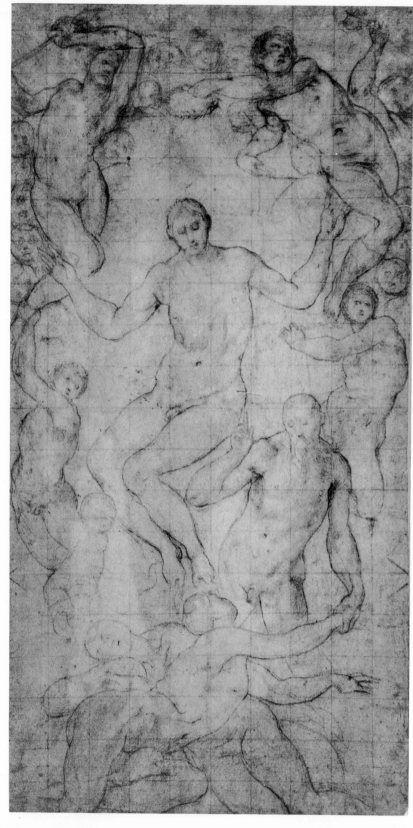

Plate

LUI

*The Virgin with the Christ Child a.
Saint John the Bap.*
black chalk and liquid white and wa.
color on tinted paper, 327 x 255 m.
Florence, Uffizi Galle.

Plate 60

PONTORMO
*Glorification of Christ and the Creation
of Eve*
black chalk, squared for enlargement
330 x 170 mm.
Leningrad, Hermitage

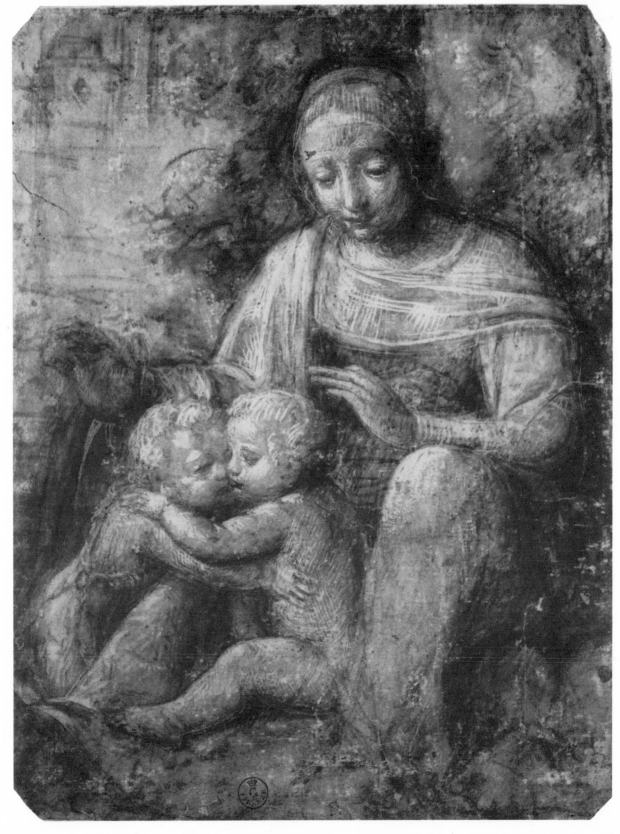

93

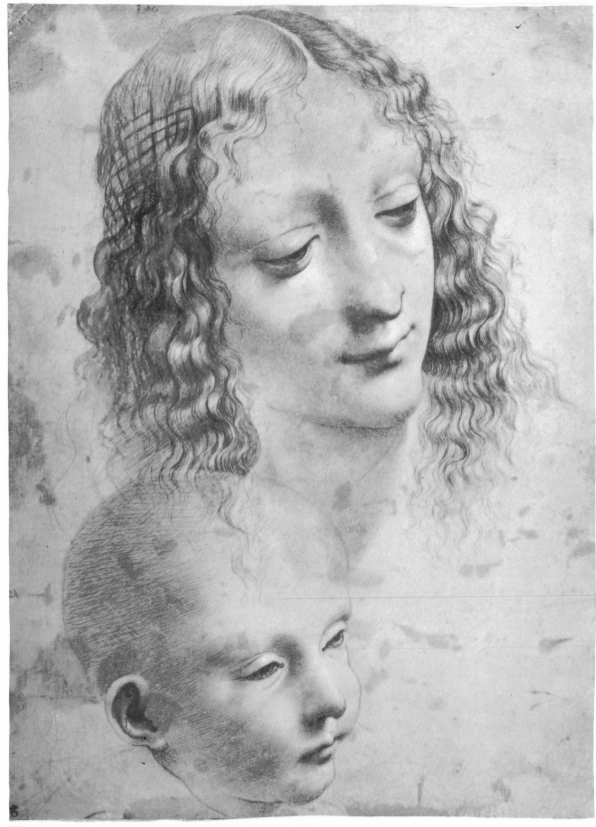

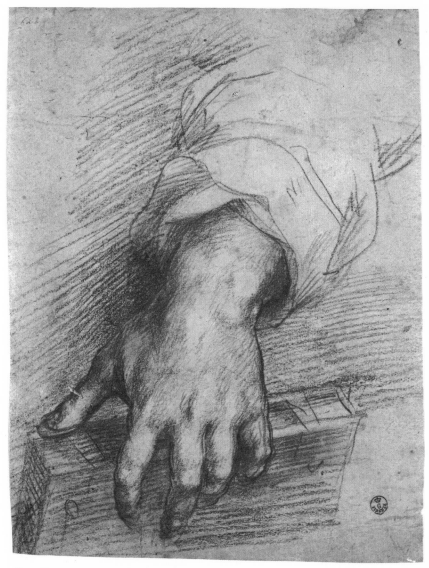

Plate 63

ANDREA del Sarto • *Study for the Left Hand of the Madonna delle Arpie*
black chalk, 270 x 210 mm. • Florence, Uffizi Gallery

62

TRAFFIO (attributed to)
*y for Heads of the Virgin and Child* • silverpoint, 297 x 220 mm.
tsworth, Devonshire Collection. Reproduced by permission of the Trustees of the Chatsworth Settlement

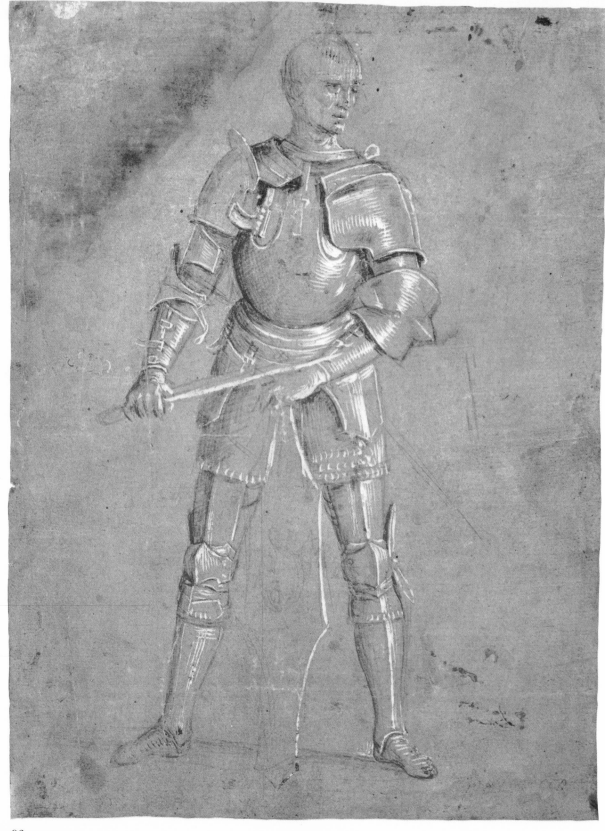

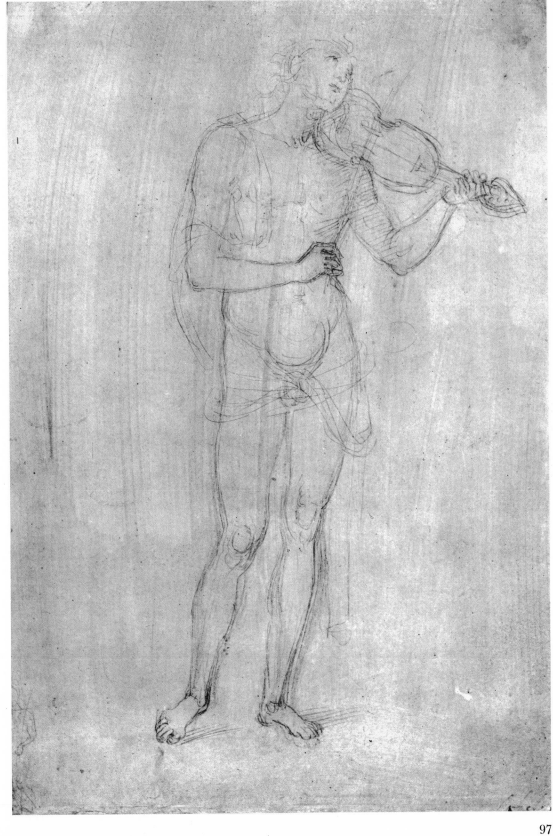

PERUGINO
*A Music-Making Angel*
point on paper prepared with
under which is a figure drawn
in black chalk, 290 x 201 mm.
Cambridge, Mass.
Harvard University
Fogg Art Museum

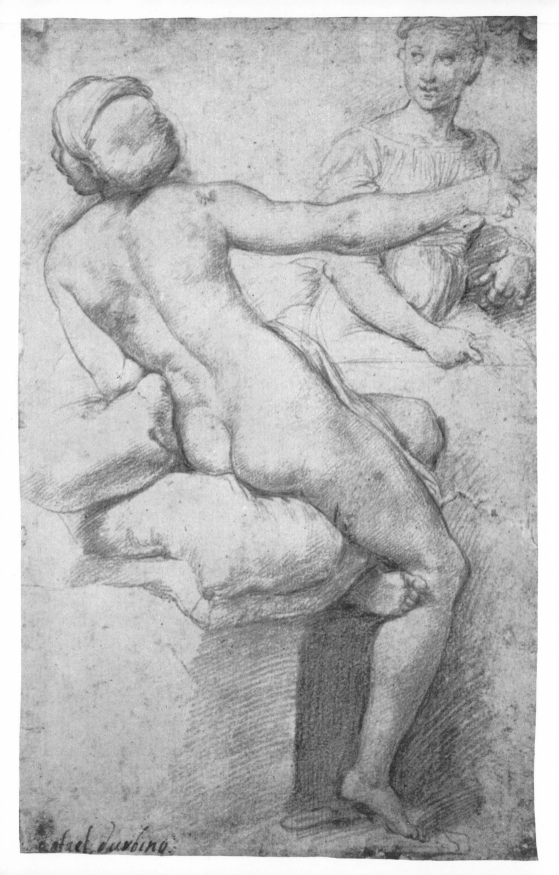

Plate 66

RAPHAEL
*Female Nude, back view*
red chalk, 256 x 163 mm.
Haarlem, Teyler Museum

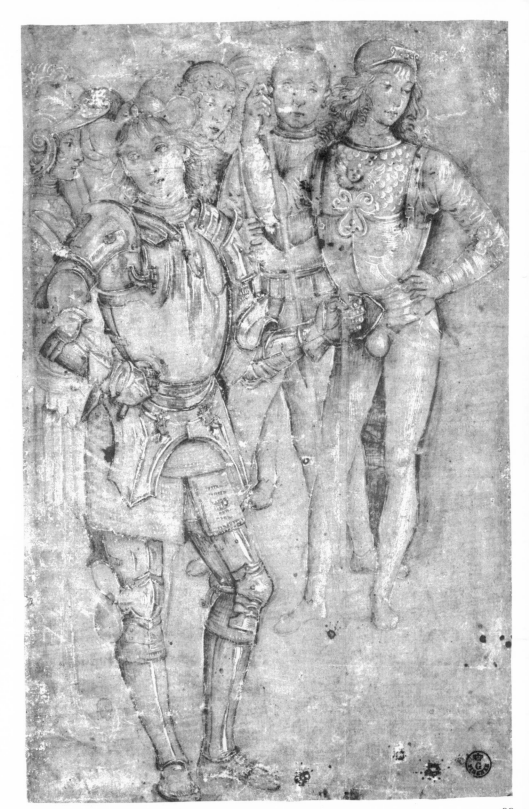

Plate 67

PINTURICCHIO
*Men in Armor*
pen, brown ink, heightened with white
on warm gray prepared ground
259 x 163 mm.
Florence, Uffizi Gallery

99

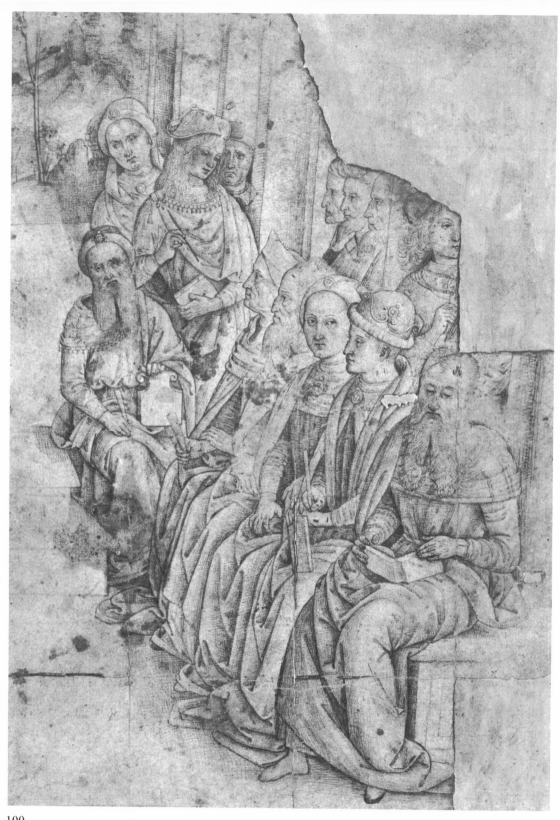

Plate 68

PINTURICCHIO
*Group of Six Seated and
Seven Standing Figures*
brush and bistre on paper faded
ivory and restored in the upper
and lower right corners
250 x 178 mm.
Cambridge, Mass.
Harvard University
Fogg Art Museum
Meta and Paul J. Sachs Collection

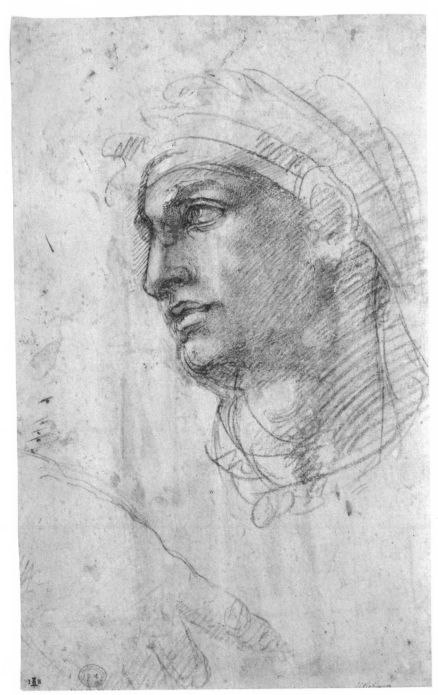

Plate 69

MICHELANGELO
*Head of Lazarus*
black chalk over red chalk, corrections in
pen and ink, 327 x 210 mm.
London, The British Museum

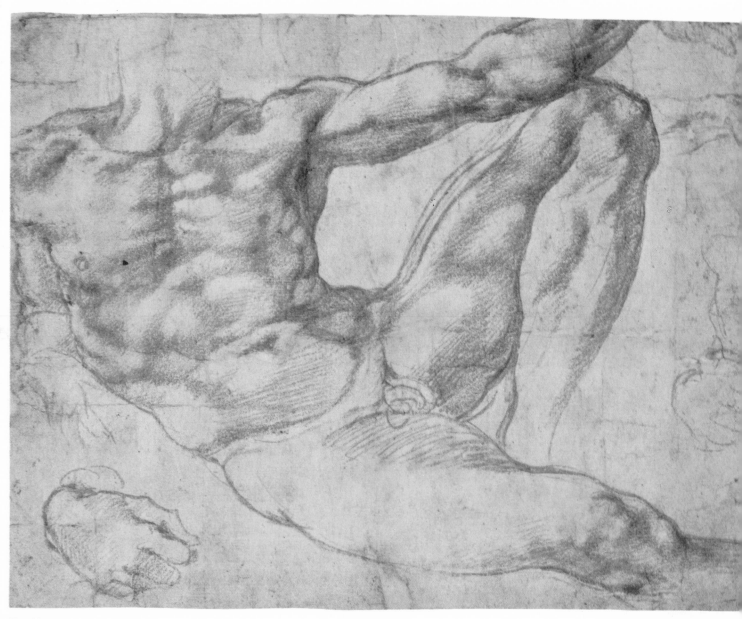

Plate 70

MICHELANGELO · *Studies of a Reclining Male Nude* · red chalk, 193 x 259 mm. · London, The British Museum·

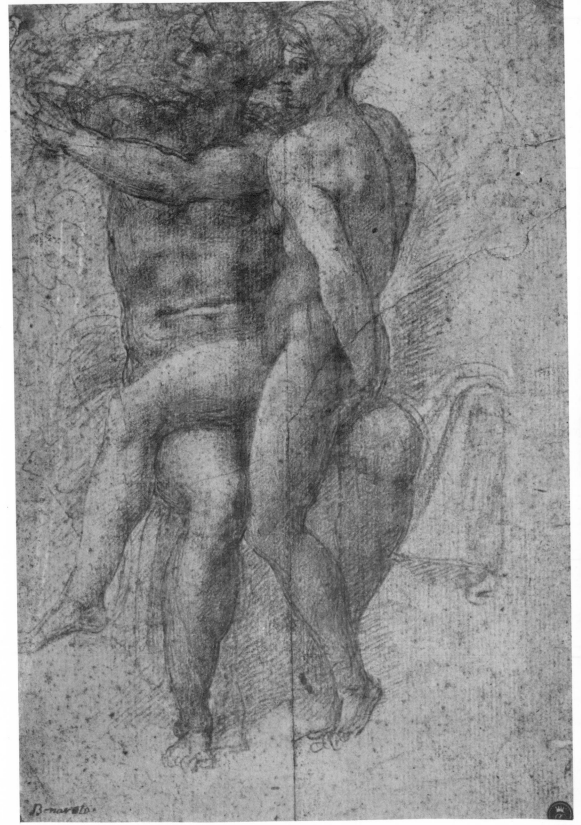

Plate 71

MICHELANGELO
*Study for Adam and Eve*
sanguine, 280 x 195 mm.
Bayonne, Musée Bonnat

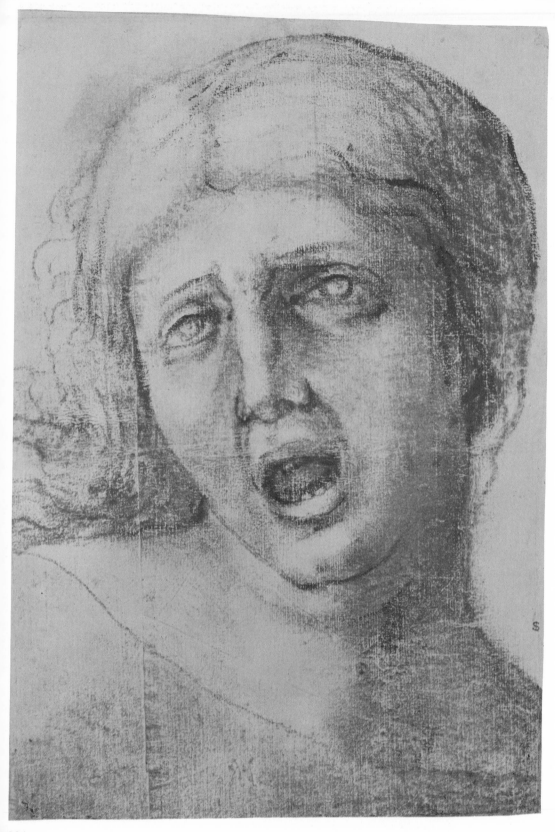

Plate 72

CORREGGIO
*Head of a Grief-Stricken Woman*
black chalk or charcoal, stumped,
reinforced with oiled charcoal,
heightened with white, and with
touches of brush and ink
322 x 222 mm.
New York
The Pierpont Morgan Library

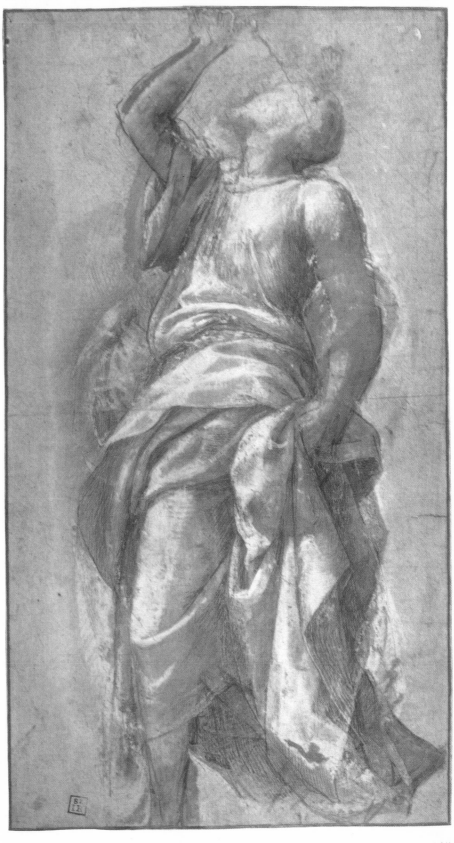

Plate 73

GATTI

*Study of an Apostle Standing*
brush and pen over black chalk, heightened
with body-color, with a little gray wash
and touches of yellow and pink pigment
402 x 223 mm.
Oxford, Ashmolean Museum

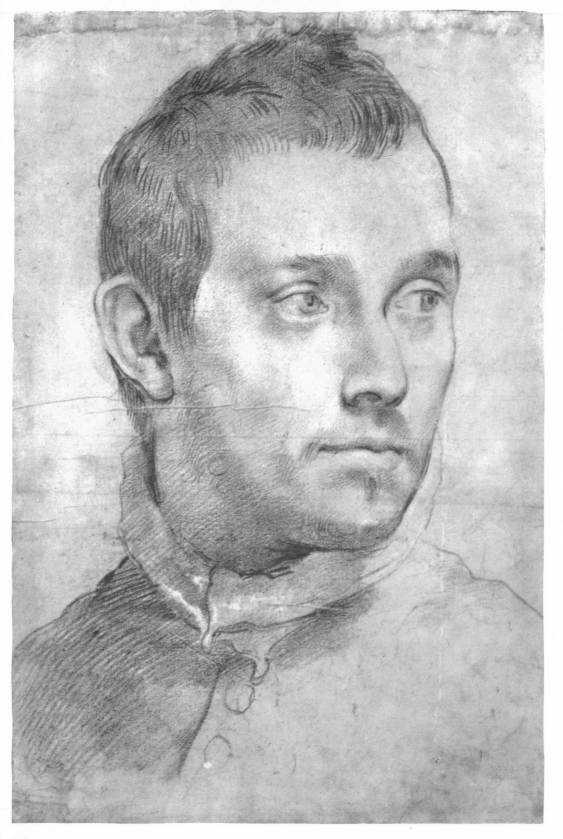

Plate 74

Annibale CARRACCI
*Portrait of a Young Man*
red chalk heightened with white
410 x 277 mm.
Princeton, New Jersey
Princeton University, The Art Museu[
Gift of Miss Margaret Mower
in memory of her mother, Elsa Dura[
Mower

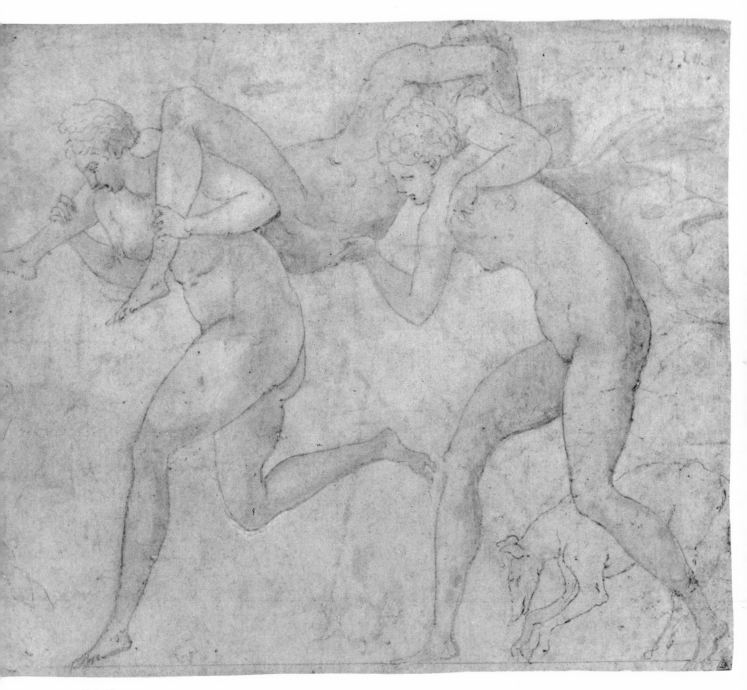

Plate 75

PRIMATICCIO · *Running Nudes* · pen and ink on buff paper with light pencil sketch and traces of wash, 232 x 280 mm. · New York
The Lehman Collection

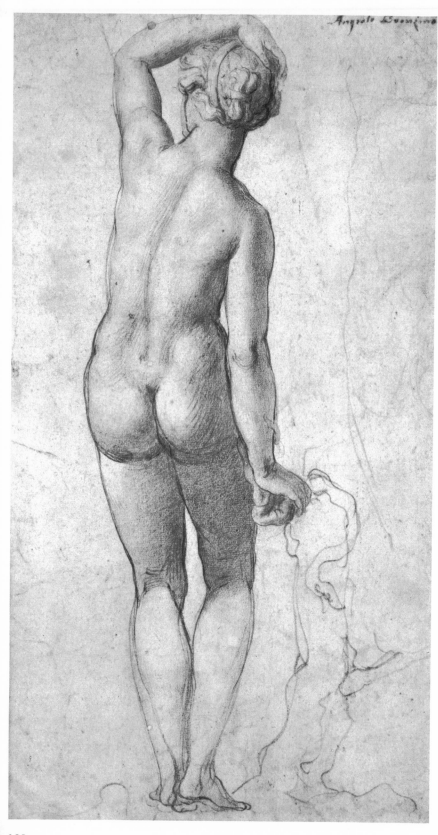

Plate 76

BRONZINO
*Copy after Bandinelli's "Cleopatra"*
black chalk on white paper, 385 x 215 mm.
Cambridge, Mass.
Harvard University
Fogg Art Museum

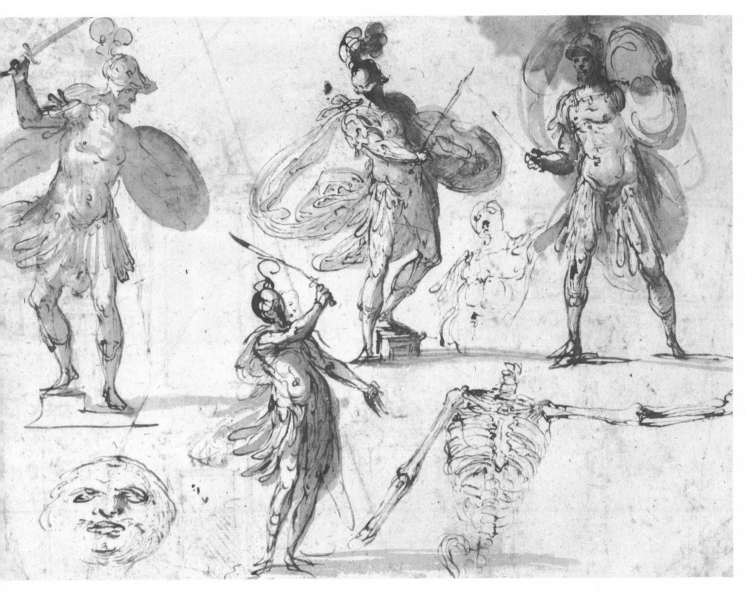

Plate 77

BUONTALENTI · *Theatrical Figures* · pen and ink, washes, 194 x 258 mm. · New York, János Scholz

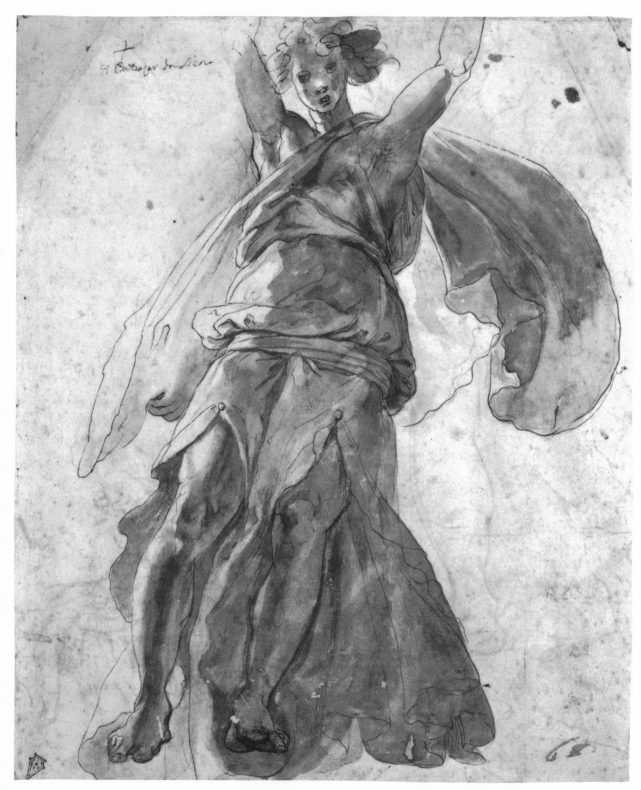

e 78

BALDI
dy for a Ceiling Genii (recto)
n and brown brush, 330 x 280 mm.
s Angeles County Museum

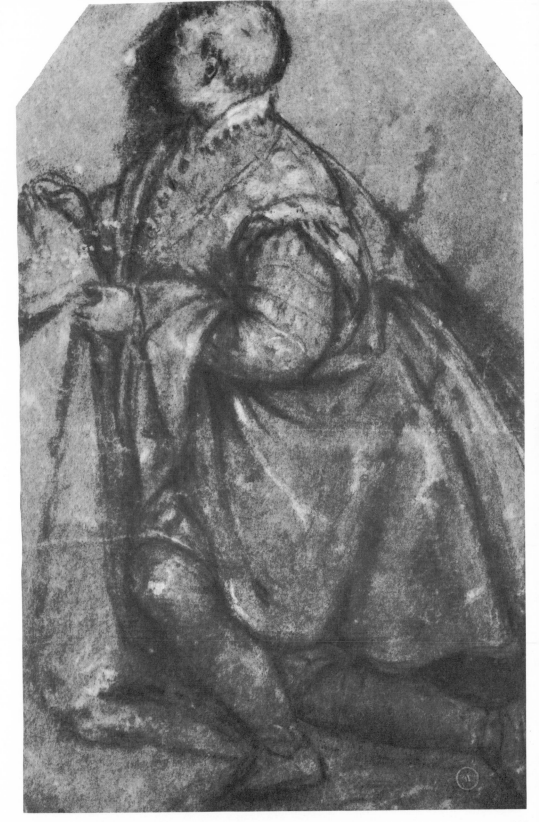

Plate 79
BASSANO
*A Page Kneeling*
black and white chalk on brown paper
276 x 178 mm.
London, Victoria and Albert Museum

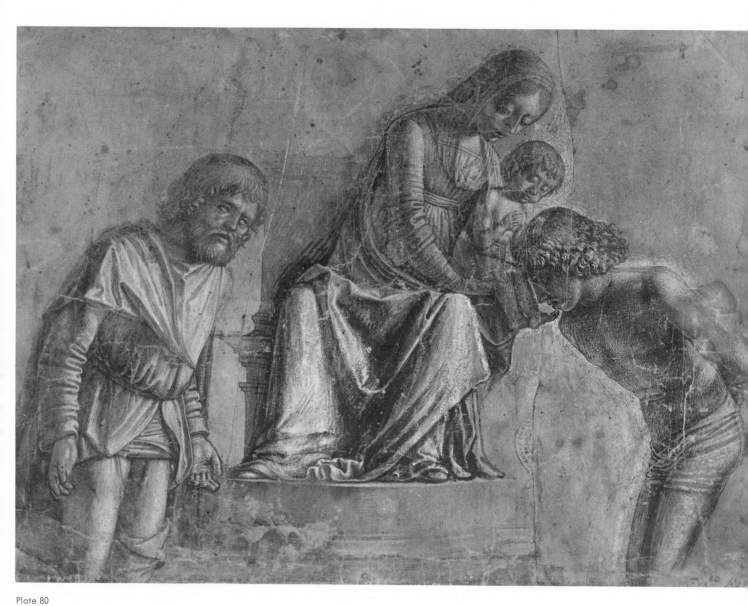

Plate 80

MORONI · *The Virgin and Child with Saints Roch and Sebastian* · pen with blue and brown wash, heightened with white
245 x 375 mm. · New York, The Lehman Collection

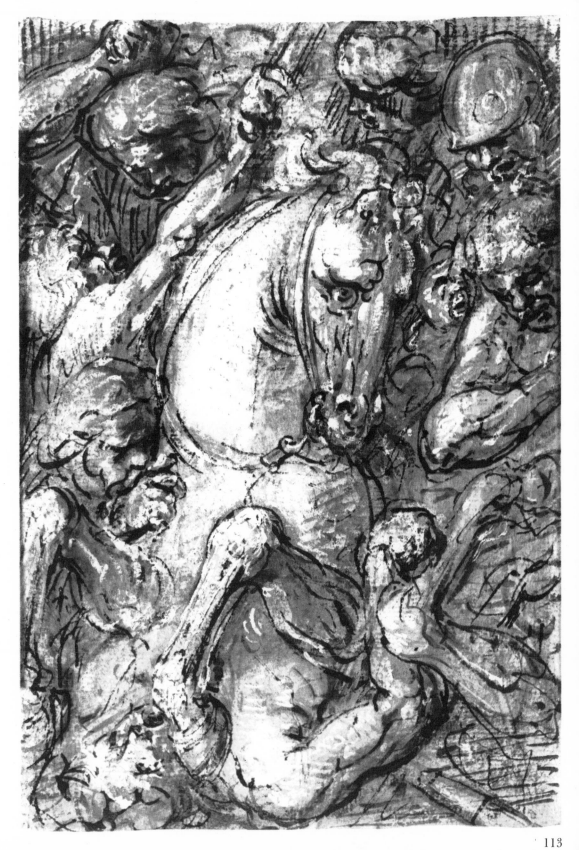

Plate 81
ITALIAN, Early 17th Century
*Battle of the Amazons* (?)
Pen and wash, heightened with
white, 262 x 181 mm.
London
Victoria and Albert Museum

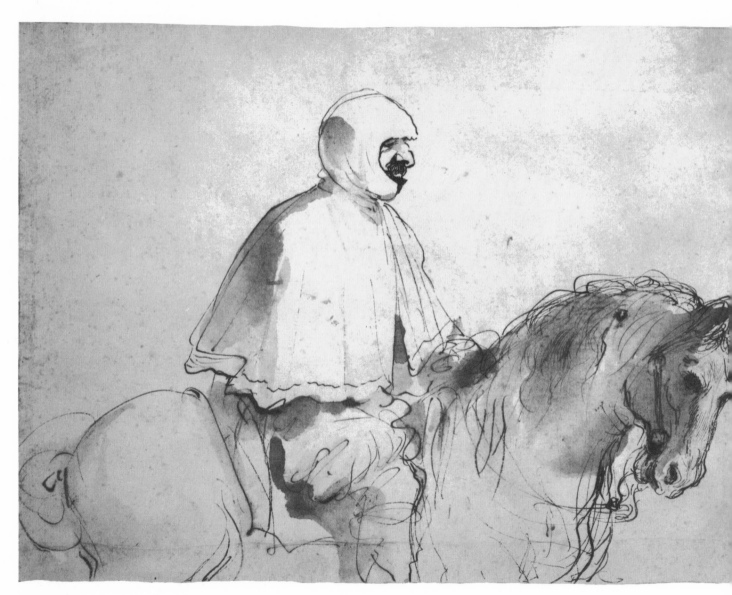

Plate 82

GUERCINO · *A Man on a Horse* · pen, sepia and wash, 190 x 267 mm. · Windsor Castle, The Royal Collection

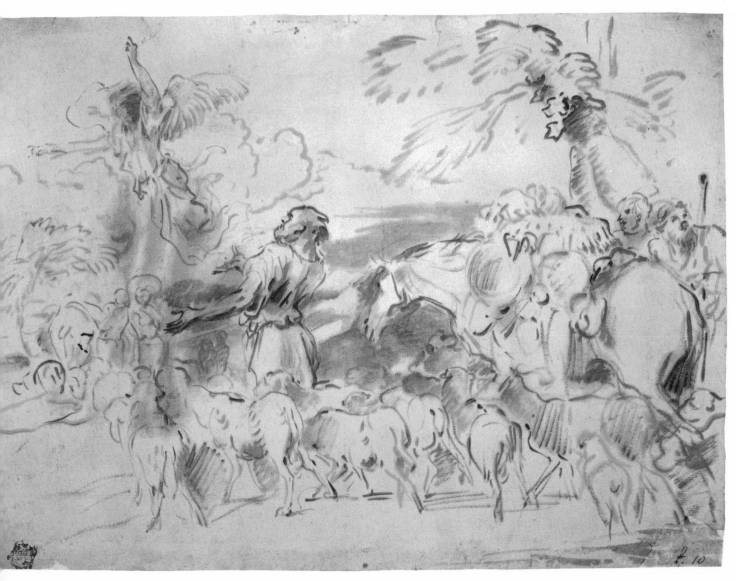

Plate 83

CASTIGLIONE · *Abraham Travelling Toward the Promised Land* · sepia wash, 207 x 556 mm. · Philadelphia Museum of Art, PAFA Collection

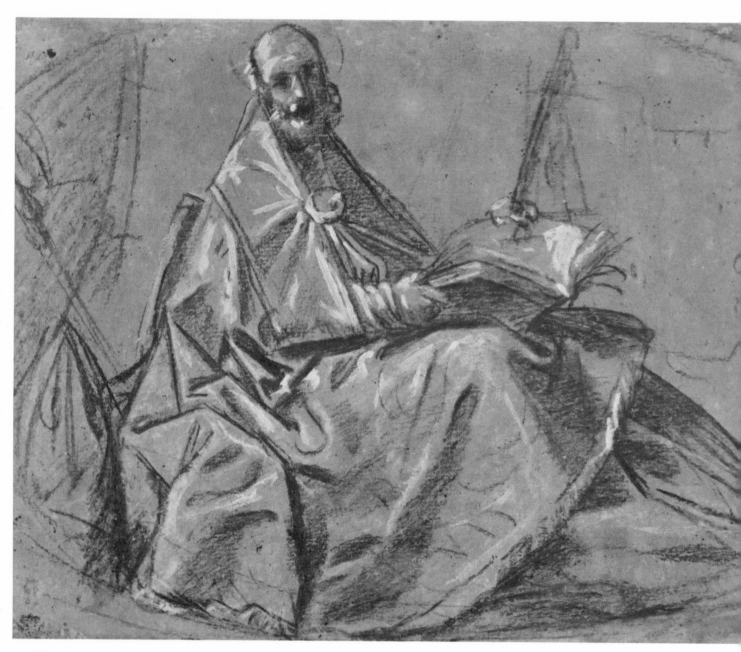

Plate 84

CAVEDONE · *A Seated Bishop Saint* · charcoal, heightened with white, on brown paper, 285 x 387 mm.
Cambridge, Mass., Harvard University, Fogg Art Museum

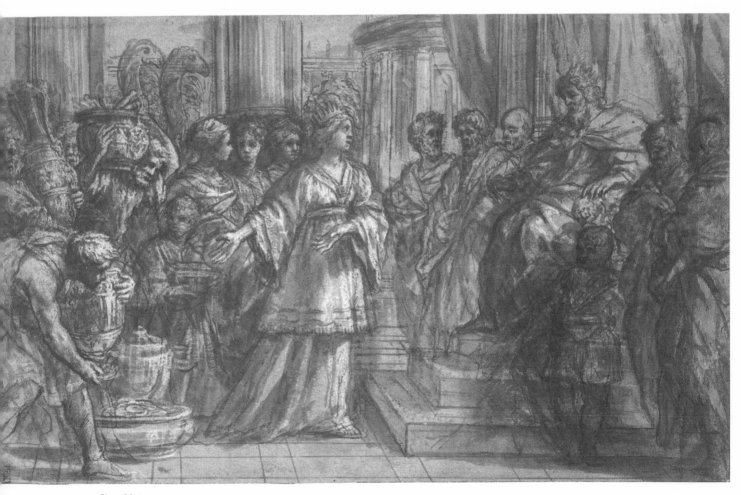

Plate 85

PIETRO da Cortona · *Queen of Sheba before Solomon* · pen, washes, and colors, 218 x 355 mm. · New York, János Scholz

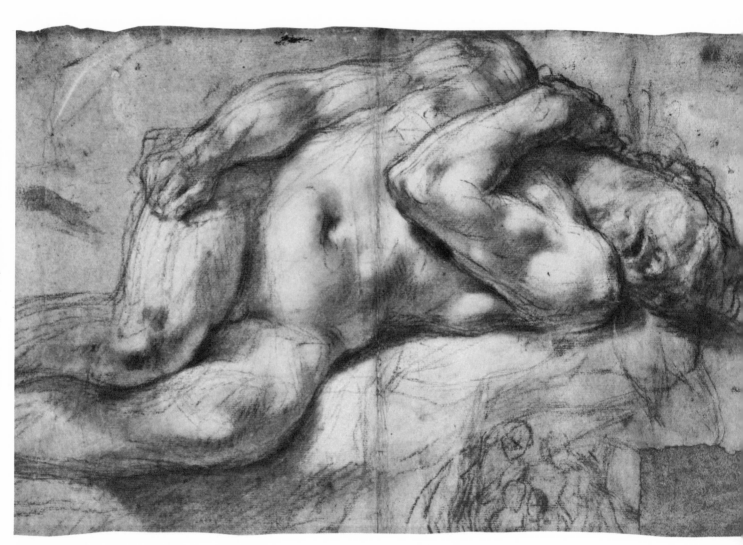

Plate 86

Agostino CARRACCI · *Dead Man, Lying* · red and white chalks, 305 x 500 mm. · New York, János Scholz

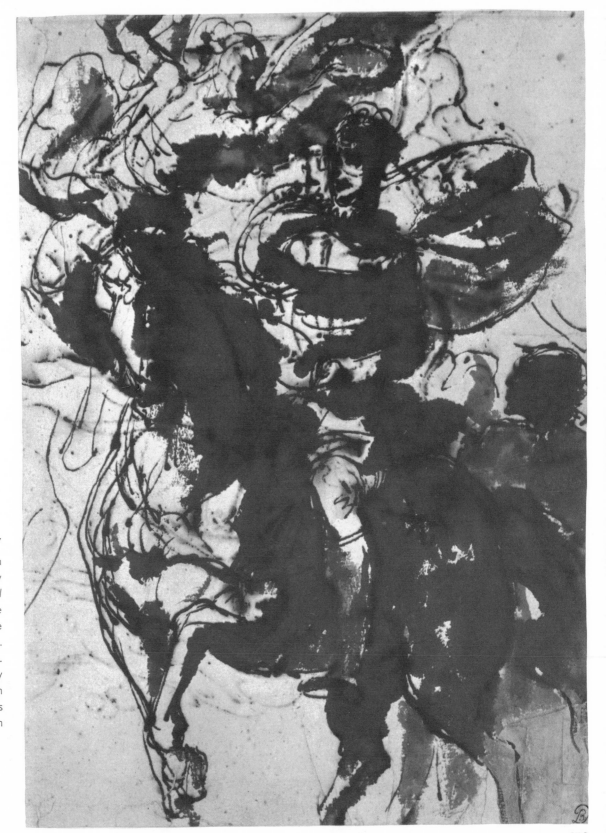

Plate 87
ITALIAN, Venetian
Early 17th Century
*A Triumphant General
Crowned by a Flying Figure*
and brown wash on white
paper, 272 x 197 mm.
Cambridge, Mass.
Harvard University
Fogg Art Museum
Meta and Paul J. Sachs
Collection

119

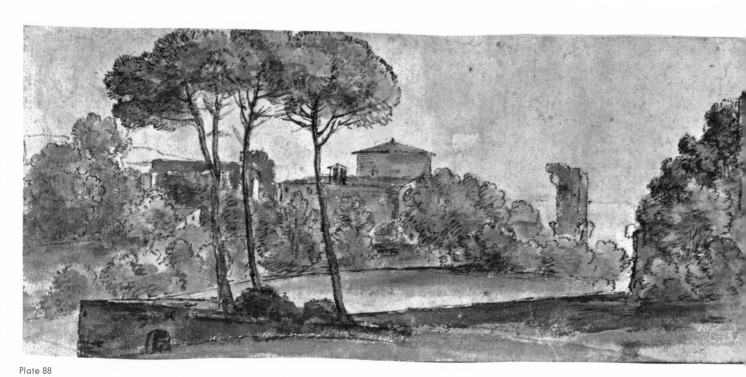

Plate 88

VANVITELLI · *Roman View with Santo Stefano Rotundo* · pen, with washes of terra verde and bistre mixed with red chalk, 127 x 308 mm. · Rhode Island, Private Collection

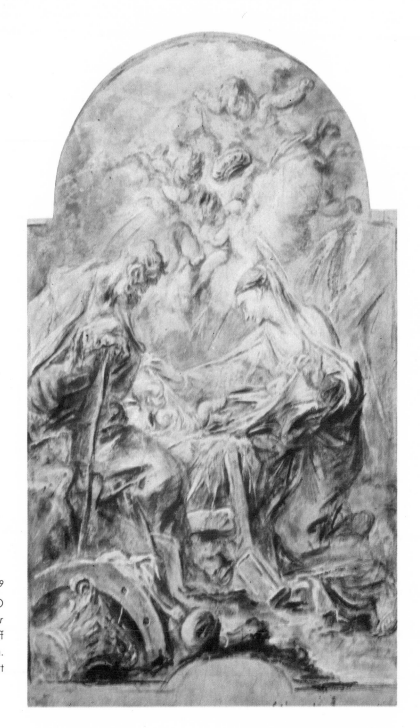

Plate 89

MAGNASCO

*The Christ Child in the Manger*

stre wash heightened with white, on buff
paper, 311 x 197 mm.
Philadelphia Museum of Art

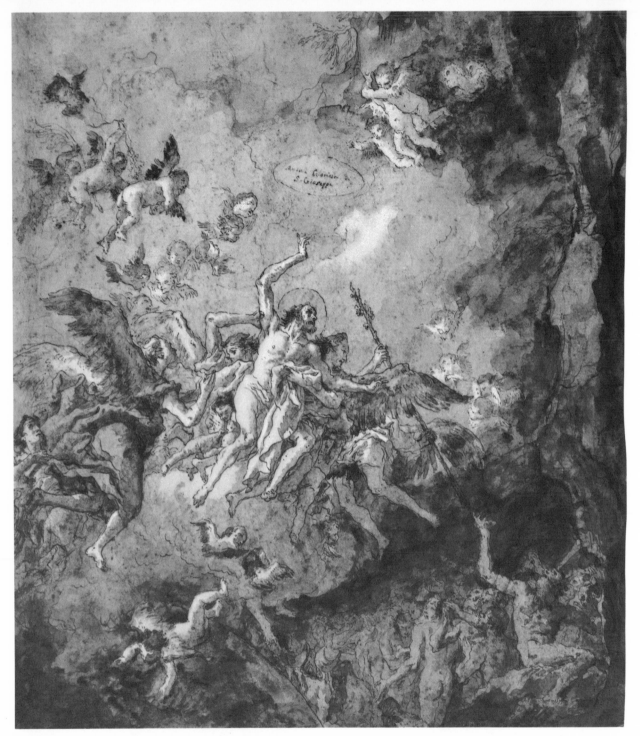

Plate 90

Giovanni Domenico TIEPOLO · *The Assumption of Saint Joseph* · pen and bistre wash, 457 x 355 mm.
Bradford, Pennsylvania, T. Edward Hanley

Plate 91

Giovanni Battista TIEPOLO · *Four Bacchic Figures* · pen and wash, 310 x 240 mm. · New York, The Lehman Colle

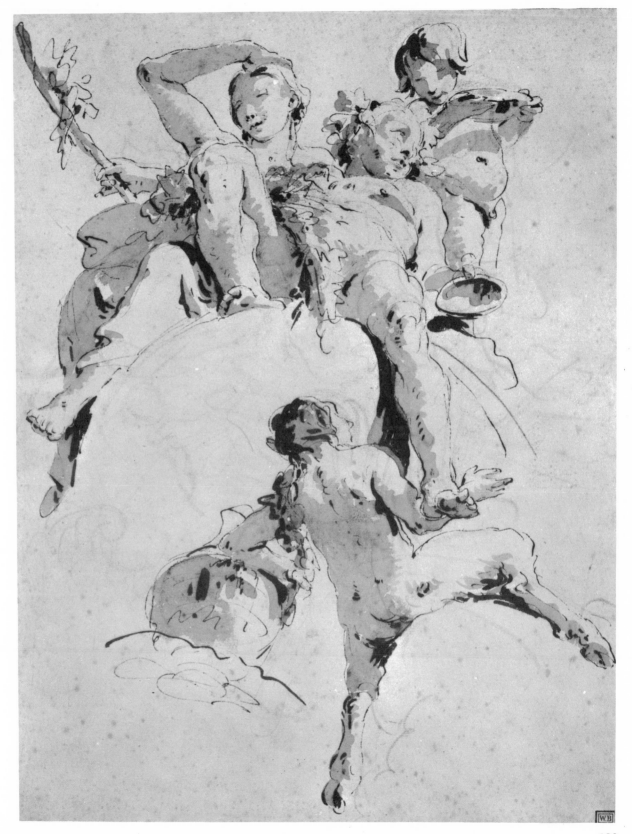

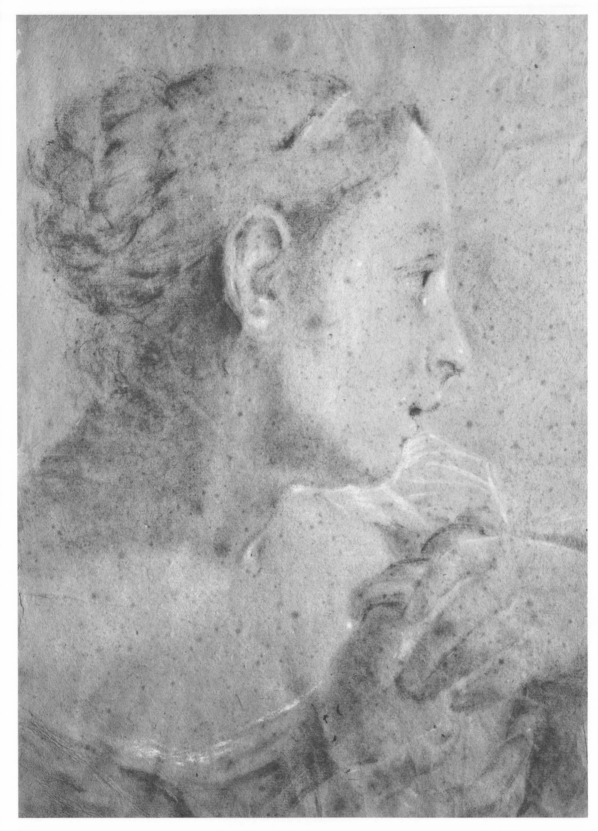

e 92

ZZETTA
ng *Woman Holding a Jar*
rcoal, heightened with white chalk on tan paper, 343 x 260 mm.
w York, Mr. and Mrs. Russell Lynes

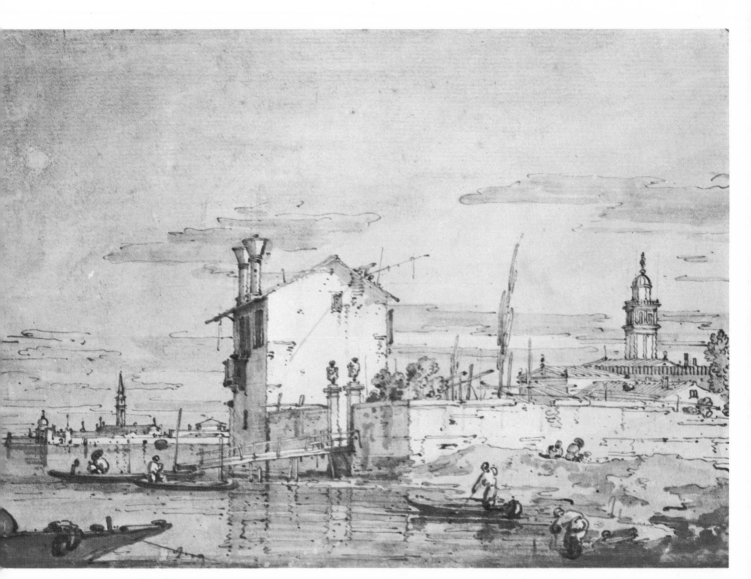

Plate 93

CANALETTO · *An Island in the Lagoon* · pen, brown ink, with carbon ink wash over ruled pencil lines, 200 x 279 mm.
Oxford, Ashmolean Museum

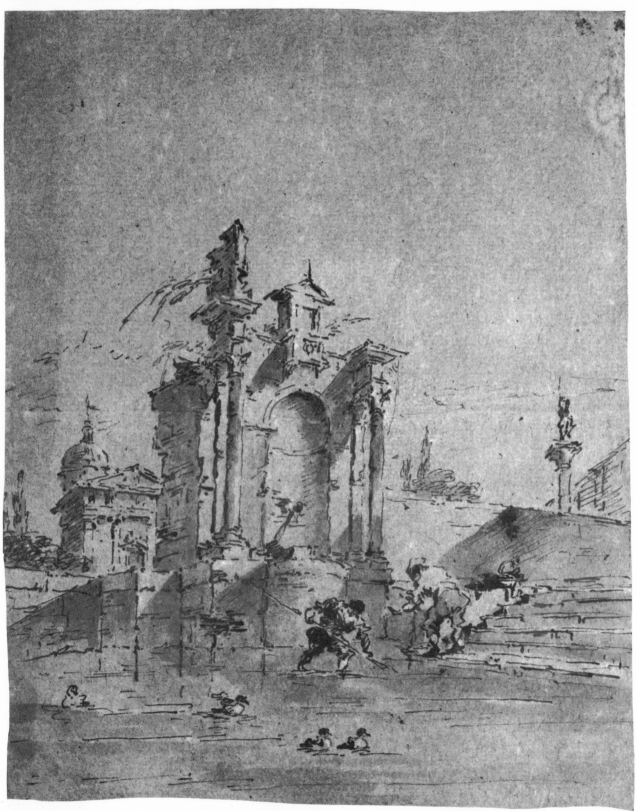

Plate 94

GUARDI
*Romantic Capri*
sepia, pen and
381 x 305 mm.
Los Angeles
County Museum

126

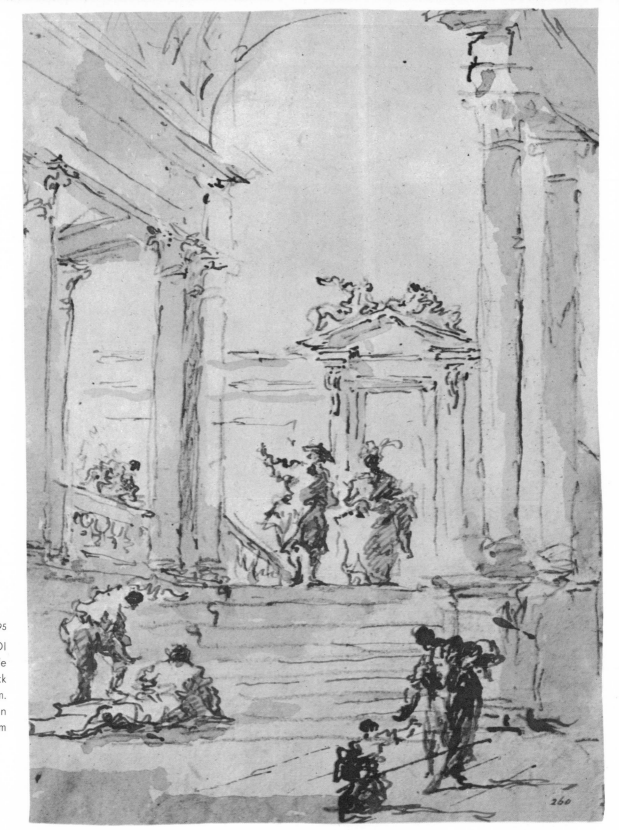

Plate 95

GUARDI
gures under a Colonnade
pen and wash over black
chalk, 255 x 166 mm.
London
ctoria and Albert Museum

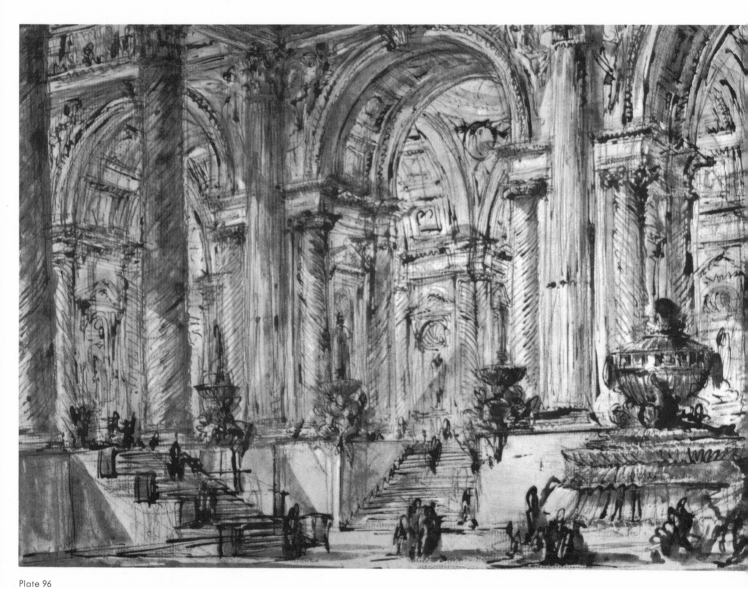

Plate 96

PIRANESI · *Architectural Fantasy* · pen and wash over red chalk preparation, 365 x 505 mm. · Oxford, Ashmolean Museum

# Biographies

### ALTICHIERO da Zevio

Altichiero da Zevio (c. 1330-c. 1395) was the founder of the important North Italian School of Verona. Although strongly influenced by Giotto, he painted more animated genre motifs and, in turn, influenced other schools of painting in Bologna, Parma, Umbria and elsewhere.

### ANDREA del Sarto

Andrea del Sarto (1486-1531) borrowed from the engravings of Dürer and apparently founded his colorism upon the Venetian, rather than Florentine, tradition. His *Madonna of the Harpies,* for which Plate 63 is a preliminary study, is considered one of the touchstones of Mannerism.

### ANTONELLO da Messina

Antonello da Messina (c. 1430-1479) experimented with the Northern technique of oil painting and had a decisive influence on painting. His works combined Northern attention to detail with Italian corporeality, as evidenced in the *Head of a Boy* drawing, Plate 31.

### BARTOLOMMEO, Fra

Fra Bartolommeo (1475-1517) a Dominican monk, was one of the most important painters in the period of transition between 15th- and 16th-century styles. It was he who adopted the use of generalized settings, vague draperies in place of contemporary dress and the use of certain devotional expressions in the treatment of religious subjects. Plate 58 is a drawing for a fresco in Sta. Maria Novella, Florence.

### BASSANO

Jacopo Bassano (1510-1592) was the most prominent member of his Venetian family of painters. Plate 79 was probably a study for a public commission and depicts the Doge as donor.

## BELLINI, Giovanni

Giovanni Bellini (c. 1430-1516) was, with Giorgione, the leading painter of 15th-century Venice. Influenced by the style of Mantegna and the technical innovations of Antonello da Messina, he rendered figures apparently enveloped in air and infused them with pathos and Christian humanism.

## BELLINI, Jacopo

Jacopo Bellini (c. 1400-1471), a pupil of Gentile da Fabriano, left two sketch books which were sources for many of the works of his sons Gentile and Giovanni.

## BOLTRAFFIO

Giovanni Antonio Boltraffio (1467-1516) was a popular painter at the Court of Milan, later working in Leonardo's studio, whose influence is apparent in Plate 62.

## BONSIGNORI

Francesco di Alberto Bonsignori (1455-1519) was a Bolognese follower of Mantegna and court painter to the Gonzaga in Mantua. Plate 37 is a preparatory study for a portrait in oil or tempera.

## BOTTICELLI

Sandro di Mariano Filipepi, called Botticelli (1445-1510), was trained as a goldsmith. He is the most representative painter of the era of Lorenzo the Magnificent. His works depended primarily upon outline or the subtleties of contour apparent in the drawing of the figure of *Abundance, or Autumn.*

## BRAMANTE

Donato Bramante (1444-1514) instituted the High Renaissance style in architecture. He was equal in his field to Raphael and Michelangelo in theirs. He admired classical design and, as a painter, decorated the walls of some of the houses he designed.

## BRONZINO

Agnolo Bronzino (1503-1572) the most important portraitist of his period, was influenced by Michelangelo and was a pupil of Pontormo, the Florentine Mannerist. The *Cleopatra* is a study from a contemporary bronze.

## BUONTALENTI

Bernardo Buontalenti (1536-1608) was a student of Michelangelo and the most important Baroque architect in Florence. He left many drawings for theatrical sets and costumes.

## CANALETTO

Giovanni Antonio Canale, called Canaletto (1697-1768), was one of the most famous Venetian *Vedutiste,* or city-scape painters. His lyric views of Venice and London were influenced partly by Dutch landscape paintings seen on his trips to England.

## CARPACCIO

Vittore Carpaccio (1455-1526) was one of the finest Venetian pageant painters. His paintings, though illustrating legendary lives of the saints, are of great value today as mirrors of the opulence of 16th-century Venice.

## CARRACCI, Agostino

Agostino Carracci (1557-1602), brother of the famous Bolognese painter, Annibale, was primarily an engraver, executing plates of High Renaissance paintings. He worked with Annibale on the Farnese Ceiling in Rome. The drawing reproduced surpasses his oil or fresco paintings of the nude.

## CARRACCI, Annibale

Annibale Carracci (1560-1609), the best-known of the Carracci, is considered the foremost figure in the classicistic vein of the Italian Baroque. The drawing reproduced, however, reveals a liveliness of expression not always attained in his painting.

## CASTIGLIONE

Giovanni Benedetto Castiglione (1616-1670) was probably a pupil of van Dyck at Genoa. Plate 83 anticipates the free-drawing technique of the 18th-century French painter, Honoré Fragonard.

## CATENA

Vincenzo Catena (c. 1465-1531) was influenced by the Venetians Giovanni Bellini and Giorgione, as well as by Raphael. Plate 36 is in Catena's style.

## CAVEDONE

Giacomo Cavedone (1577-1660) became an apprentice in the atelier of the Carracci and was later Guido Reni's assistant working in the full Baroque manner.

## CORREGGIO

Antonio Allegri, called Correggio (c. 1489-1534), worked primarily in Mantua and Parma, developing his soft style from Leonardo. His frescoes show much influence of Michelangelo and Raphael. Plate 72 recalls the sculpturesque heads of Michelangelo's Sistine *Sibyls*.

## ERCOLE de' Roberti

Ercole d'Antonio de' Roberti (c. 1448/55-1496) was a contemporary of his fellow Ferrarese painters, Tura and Cossa. Roberti's style was influenced by Giovanni Bellini.

## FRANCESCO del Cossa

Francesco del Cossa (1435-1477), Ferrarese painter and pupil of Tura, was influenced by the Florentines and by Piero della Francesca. Plate 30 is associated with his frescoes for the Palazzo Schifanoia in Ferrara.

## FRANCESCO di Giorgio

Francesco di Giorgio (1439-1501/2) was a Sienese architect, fortifications designer, sculptor, painter and author of a treatise on architecture. He had been a pupil of Vecchietta.

## FRANCIA

Francesco Raibolini, called Francia (1450-1518), was a Bolognese who combined the styles of Perugino and the Ferrarese painters. Later he was influenced by Raphael, as may be seen in Plate 35.

## GATTI

Bernardino Gatti, called Il Sojaro (1490/95-1576), studied with Correggio in Parma. Plate 73 is a sketch for an apostle in the *Ascension* at San Sigismondo, Cremona.

## GHIRLANDAIO, Davide

Davide Ghirlandaio (1452-1525) was a Florentine painter and mosaicist. He collaborated with his brother Domenico Ghirlandaio on a number of works.

## GHIRLANDAIO, Domenico

Domenico di Tommaso Bigordi, called Ghirlandaio (1449-1494), was the foremost fresco painter in 15th-century Florence, imparting his mastery of the medium to his apprentice, Michelangelo. Plate 18 illustrates the consistent use of diagonal hatching to indicate form.

## GIORGIONE

Giorgio Barbarelli, called Giorgione (1478-1510), was the primary influence upon most of the 16th-century Venetian masters and is known as the creator of "mood" in painting. Plate 43 is probably a contemporary copy of the figures from his *Adoration*, rather than from his own hand.

## GOZZOLI

Benozzo Gozzoli (c. 1421-97) was an assistant to Fra Angelico and to Lorenzo Ghiberti. Plate 8 is an example of the Renaissance skill in the rendering of drapery.

## GUARDI

Francesco Guardi (1712-1793) was one of the foremost painters of highly atmospheric Venetian *veduta* or city scenes. A *Capriccio* is an imaginary architectural subject.

## GUERCINO

Francesco Barbieri, called Guercino (1591-1666), was a pupil of Lodovico Carracci, who developed a Baroque style out of Mannerism.

## LEONARDO

Leonardo da Vinci (1452-1519) was apprenticed to Andrea Verrocchio. He is considered with Raphael and Michelangelo, one of the creators of the High Renaissance. He died while serving as First Painter and Engineer to François I[ier]. A large corpus of drawings evidences Leonardo's intense interest in the limitless variety of human physique and physiognomy.

**LIPPI, Filippino**

Filippino Lippi (1484-1504), son of Filippo Lippi and possibly a pupil of Botticelli, completed Massaccio's Brancacci Chapel frescoes in Florence. Many of his drawings combine the monumentality of Massaccio with Botticelli's line.

**LIPPI, Filippo**

Fra Filippo Lippi (c. 1406-1469), a pupil of Lorenzo Monaco, was influenced by Masaccio and Fra Angelico. The expressive linearity Lippi acquired from Lorenzo Monaco which Botticelli, apprenticed to him, brought to ultimate perfection, is present in his drawings.

**LORENZO di Credi**

Lorenzo di Credi (1458-1537) was Verrocchio's principal painting assistant at the time Leonardo was in his workshop. The influence of both painters is evident in Credi's oeuvre.

**LOTTO**

Lorenzo Lotto (c. 1480-1556), a Venetian painter, was a pupil of Alvise Vivarini and was influenced by Giovanni Bellini, Giorgione, Palma Vecchio, Botticelli and Titian.

**LUINI**

Bernardino Luini (c. 1482-1532) was a Milanese painter. As a follower of Leonardo he often bathed his subjects in soft shadow.

**MAGNASCO**

Alessandro Magnasco (1677-1749) was a Genoese painter of violent storms at sea and of brooding landscapes peopled by robbers and monks. Plate 89 is a study for an altarpiece.

**MAINARDI**

Sebastiano Mainardi (d. 1513) was a brother-in-law and pupil of Domenico Ghirlandaio whose style he reflected.

**MANTEGNA**

Andrea Mantegna (c. 1431-1506) was a painter from Padua and the adopted son of the archaeologist-painter, Squarcione. He too was deeply influenced by the study of classical reliefs and by Donatello's sculpture.

## MICHELANGELO
Michelangelo Buonarroti (1475-1564) was, with Leonardo and Raphael, a creator of the High Renaissance in sculpture, and the single most influential painter in the development of Mannerism.

## MORONI
Francesco Moroni (1471/73-1529) was a painter from Verona and was influenced by Mantegna.

## PALMA Giovane
Jacopo Palma, called Giovane (1544-1623), is known to have completed some of the last works of Titian. His painterly drawings also show the influence of Veronese and of Florentine Mannerism.

## PARMIGIANINO
Girolamo Francesco Maria Mazzola, called Parmigianino (1503-1540), one of the early Mannerist painters, was influenced by Correggio. He worked in Parma and in Rome, and fled to Bologna in 1527 during the Sack of Rome. The last ten years of his life were spent painting frescoes in Sta. Maria della Steccata, Parma. He was the foremost draughtsman of the Mannerists.

## PELLEGRINO da San Daniele
Martino da Udine called Pellegrino da San Daniele (c. 1467-1547), reflects the Venetian painting style of the early 16th century.

## PERUGINO
Pietro Vannucci, called Perugino (1445-1523), was probably a pupil of Piero della Francesca, later studying with Verrocchio. The stance in Plate 65 combines with an air of classic serenity which presaged the works of his pupil, Raphael.

## PIAZZETTA
Giovanni Battista Piazzetta (1683-1754), a Venetian much influenced by Rembrandt, bridges the Baroque and Rococo styles in Italy. He influenced Tiepolo and is known to have created many drawings for collectors.

## PIERO di Cosimo

Piero di Cosimo (1462-1521), a Florentine student of Verrocchio, was later influenced by Leonardo and Signorelli. Primarily he painted scenes based upon mythology, such as Plate 21.

## PIETRO da Cortona

Pietro Berrettini da Cortona (1596-1669) was one of the founders of Roman Baroque, second only to Bernini in his architectural genius. Plate 85 is in the tightly composed, stage-like manner of his early years.

## PINTURICCHIO

Bernardino Pinturicchio (1454-1513) was trained in the Umbrian school of painting and became a follower of Perugino.

## PIRANESI

Giovanni Battista Piranesi (1720-1778) executed hundreds of etchings and drawings of Roman ruins. His romantic vision of the ancient world influenced the entire 18th-century attitude toward antiquity.

## PISANELLO

Antonio Pisanello (1395-1455) was probably the pupil of the International Gothic painter, Gentile da Fabriano. He is best known as a draughtsman and medallist. Many of his drawings show the newly developed interest of his time in the observation of all aspects of nature.

## POLLAIUOLO, Antonio

Antonio Pollaiuolo (c. 1432-98), Florentine sculptor, painter, engraver and goldsmith, had one of the most famous 15th-century *bottegas*. Perhaps best known are his drawings and engravings of nudes which are among the earliest and finest of anatomical drawings.

## PONTORMO

Jacopo Pontormo, called Il Pontormo (1494-1556), was a pupil of Andrea del Sarto. One of the finest draughtsmen of the Renaissance, Pontormo was one of the creators of Mannerism.

## PRIMATICCIO

Francesco Primaticcio (1504-70), a Bolognese Mannerist, was the chief and most versatile member of the School of Fontainebleau. Through him Italian Mannerism became the impetus for the entire French Renaissance. The sinuous line and attenuated figures in his drawings are typical of both Mannerist and French Renaissance drawing.

## RAFFAELLINO del Garbo

Raffaellino del Garbo (1466-1524) was a student of Filippino Lippi and influenced by Ghirlandaio. Garbo's *St. Christopher,* when contrasted with the Bramante Plate 5, lacks the strength customarily attributed to that saint but is more graceful.

## RAPHAEL

Raffaello Sanzio (1483-1520), although he died at age thirty-seven, was acknowledged as the equal of Leonardo and Michelangelo. A pupil of Perugino, Raphael was later influenced by Leonardo. His most renowned paintings are the series of Madonnas, the Vatican *Stanze,* the decorations of Villa Farnesina and the *Sistine Madonna.*

## SEBASTIANO del Piombo

Sebastiano Luciani (1485-1547), called Sebastiano del Piombo, was a Venetian painter and a pupil of Giovanni Bellini and Giorgione. In Rome he became a friend of Michelangelo and was greatly influenced by him.

## SIGNORELLI

Luca Signorelli (c. 1441/50-1523) was probably a pupil of Perugino. His drawings however, reflect the exaggeratedly muscular figures of the Pollaiuoli brothers and forecast Michelangelo's dramatic nudes.

## SODOMA

Giovanni Antonio Bazzi, called Il Sodoma (1477-1549), was a Sienese painter much influenced by Leonardo, Pinturicchio, and by Jacopo della Quercia's sculptures.

## TIBALDI

Pellegrino Tibaldi (1527-1596) was influenced by Parmigianino and Nicolo dell' Abbate and Michelangelo. Plate 78 combines the statuesque air of figures by Michelangelo with the sinuous rhythms of the Mannerists.

## TIEPOLO, Giovanni Battista

Giovanni Battista Tiepolo (1696-1770), was the greatest Italian Rococo painter. He traveled throughout Europe executing commissions in areas as widely separated as Würzburg and Madrid. The drawings reproduced might serve as a stylistic guide to the entire artistic production of the 18th century.

## TIEPOLO, Giovanni Domenico

Giovanni Domenico Tiepolo (1727-1804), the son of Giovanni Battista Tiepolo, was his father's principal assistant and imitator, although their styles were actually somewhat different because of dissimilar points of view.

## TINTORETTO

Jacopo Robusti, called Tintoretto (1518-1594), is often considered one of the first Baroque painters because of his dramatic lighting, extremes in scale, unusual viewpoints and violent movement. The drawings reproduced show the hasty, rather "Impressionist" technique of both his drawing and painting.

## TITIAN

Tiziano Vecellio' (c. 1487/90-1576), Giorgione's greatest follower, is considered by most to be the quintessence of Venetian painting and, with Michelangelo, Leonardo and Raphael, one of the four supreme figures of the High Renaissance.

## UCCELLO

Paolo Uccello (1396/7-1475) was apprenticed to Ghiberti and was one of the first and foremost experimenters in the new science of foreshortening. His most famous works are the three *Battles* in the Uffizi, London and Paris. The reproduced drawing is probably a study for the Uffizi work.

## VANVITELLI

Gaspare Vanvitelli (Gaspar van Wittel) (1653-1736) was a Dutch painter, living in Italy, whose landscape drawings are in the manner of Claude.

## VERONESE

Paolo Caliari, called Veronese (c. 1528-1588), was a Venetian chiefly influenced by Titian, Michelangelo and Parmigianino. Plate 48 is one of many of his drawings which were probably created for art collectors of his time rather than in preparation for paintings.

## VERROCCHIO

Andrea del Verrocchio (c. 1435-1488), perhaps a pupil of Donatello, became the leading 15th-century Florentine sculptor. Apprenticed to his *bottega* were Perugino, Leonardo and Lorenzo di Credi, who worked on commissions from the Medici. Plate 15 has been punctured in preparation for transfer to a wall or canvas.

## VIVARINI

Alvise Vivarini (c. 1457-1503), although possibly a pupil of his brother Bartolommeo, was primarily influenced by Giovanni Bellini and Antonello da Messina.

## ZOPPO

Marco Zoppo (1433-1478) was perhaps a student of Cosimo Tura in Ferrara.

# Bibliography

## GENERAL

Bean, J., *Les Dessins Italiens de la Collection Bonnat*. Paris, 1960.

Benesch, O., *Venetian Drawings of the 18th Century in America*. New York, 1947.

Berenson, B., *Drawings of the Florentine Painters*. 2nd ed., 3 vols., Chicago, 1938.

Blunt, Sir A., and Cooke, H. L., *The Roman Drawings of the XVII and XVIII Centuries in the Collection of Her Majesty the Queen at Windsor Castle*. London, 1960.

Blunt, Sir A., and Croft-Murray, E., *Venetian Drawings of the XVII and XVIII Centuries in the Collection of Her Majesty the Queen at Windsor Castle*. London, 1957.

Kurz, O., *Bolognese Drawings of the XVII and XVIII Centuries in the Collection of Her Majesty the Queen at Windsor Castle*. London, 1955.

Parker, K. T., *North Italian Drawings of the Quattrocento*. London, 1927.

Popham, A. E., and Wilde, J., *The Italian Drawings of the XV and XVI Centuries in the Collection of His Majesty the King at Windsor Castle*. London, 1949.

Tietze, H., and Tietze-Conrat, E., *Drawings of the Venetian Painters in the 15th and 16th Centuries*. New York, 1944.

## ALTICHIERO da Zevio

Bronstein, L., *Altichiero; l'artiste et son oeuvre*. Paris, 1932.

## ANDREA del Sarto

Becherucci, L., *Andrea del Sarto*. Milan, 1955.

## ANTONELLO da Messina

Bottari, S., *Antonello*. Milan, 1953.

## Fra BARTOLOMMEO

Gabelentz, H. von der, *Fra Bartolommeo*, 2 vols., Leipzig, 1922.

## Giovanni BELLINI

Pallucchini, R., *Giovanni Bellini*. Milan, 1959.

Walker, J., *Bellini and Titian at Ferrara; a study of styles and tastes*. London, 1956.

## Jacopo BELLINI

Goloubew, V., Die Skizzenbuecher Jacopo Bellinis, 2 vols., Brussels, 1912.

## BOTTICELLI

Argan, G. C., *Botticelli; biographical and critical study*. New York, 1957.

Hartt, F., *Botticelli*. New York, 1962.

## BRAMANTE

Suida, W. E., *Bramante Pittore e il Bramantino*. Milan, 1953.

## BRONZINO

McComb, A. K., *Agnolo Bronzino*. Cambridge, Mass., 1928.

## CANALETTO

Parker, K. T., *The Drawings of Antonio Canaletto in the Collection of His Majesty the King at Windsor Castle*. Oxford, 1948.

## Agostino CARRACCI and Annibale CARRACCI

Wittkower, R., *The Drawings of the Carracci…at Windsor Castle*. London, 1952.

## CARPACCIO

Pignatti, T., *Carpaccio*. New York, 1958.

Lauts, J., *Carpaccio: Paintings and Drawings*. London, 1962.

## CASTIGLIONE

Blunt, Sir A., *The Drawings of Giovanni Benedetto Castiglione*. London, 1945.

## CATENA

Robertson, G., *Vincenzo Catena*. Edinburgh, 1954.

## CORREGGIO

Popham, A. E., *Correggio's Drawings*. London, 1957.

## GIORGIONE

Richter, G. M., *Giorgio da Castelfranco, called Giorgione*. Chicago, 1937.

## GUARDI

Byam Shaw, J., *The Drawings of Francesco Guardi*. London, 1951.

## GUERCINO

Russell, A. G. B., *Drawings by Guercino*. London, 1923.

## LEONARDO da Vinci

Clark, Sir K., *A Catalogue of the Drawings of Leonardo da Vinci in the Collection of His Majesty the King at Windsor Castle*. New York, 1935.

Goldschneider, L., *Leonardo da Vinci: Drawings* (5th ed.), New York, 1954.

Popham, A. E., *The Drawings of Leonardo da Vinci* (2nd ed.), London, 1949.

## Filippino LIPPI

Neilson, K. B., *Filippino Lippi*. Cambridge, Mass., 1938.

Fossi, M., *Mostra di Disegni di Filippino Lippi e Piero de Cosimo*. Florence, 1955.

## LOTTO

Berenson, B., *Lorenzo Lotto. London*, 1956.

## MANTEGNA

Tietze-Conrat, E., *Mantegna: paintings, drawings, engravings*. London, 1955.

## MICHELANGELO

Delacre, M., *Le Dessin de Michel-Ange*. Brussels, 1938.

Goldschneider, L., *Michelangelo Drawings*. London, 1951.

Panofsky, E., *Handzeichnungen Michelangelos*. Leipzig, 1922.

Wilde, J., *Italian Drawings in the Department of Prints and Drawings in the British Museum: Michelangelo and His Studio*. London, 1953.

## PALMA Giovane

Forlani, A., *Mostra di Disegni di Jacopo Palma il Giovane*. Florence, 1958.

## PARMIGIANINO

Popham, A. E., *The Drawings of Parmigianino*. London, 1953.

## PIERO della Francesca

Valsecchi, M., *Piero della Francesca*. New York, 1962.

## PIERO di Cosimo

Fossi, M., *Mostra di Disegni di Filippino Lippi e Piero di Cosimo*. Florence, 1955.

## PIRANESI

Thomas, H., *The Drawings of G. B. Piranesi*. London, 1954.

## PISANELLO

Degenhart, B., *Pisanello*. Turin, 1945.

## RAPHAEL

Popham, A. E., *Selected Drawings from Windsor Castle; Raphael and Michelangelo*. London, 1954.

Pouncey, P. and Gere, J. A., *Italian Drawings in the Department of Prints and Drawings in the British Museum: Raphael and his Circle*. London, 1963.

## Giovanni Battista TIEPOLO

Morassi, A., *G. B. Tiepolo, his life and work*. London, 1955.

## TINTORETTO

Fosca, F., *Tintoret*. Paris, 1929.

Hadeln, D. von, *Zeichnungen des Giacomo Tintoretto*. Berlin, 1922.

Salinger, M., *Tintoretto*. New York, 1962.

## TITIAN

Hadeln, D. von, *Zeichnungen des Titians*. Berlin, 1924.

Morassi, A., *Tiziano*. Milan, 1956.

Rousseau, T., *Titian*. New York, 1962.

## VERONESE

Palucchini, R., *Mostra di Paolo Veronese*. Venice, 1939.